APERTURE

Witness to Crisis

It is a reality of the late twentieth century that we are all witness to crisis. There is no escape from the bombardment of imagery and language telling us of the agony of others that reaches the free-reading Western world. The journalists and photojournalists who are messengers of these grim truths uphold two prevalent motives: the belief that the photograph can affect the course of history, and the less ambitious response that it is our duty simply to record. Both emerge from the conviction that tragedy should not pass unwitnessed by those cushioned and secure, living in relative safety.

Sebastiao Salgado's terrifying document from the Sahel, *Man in Distress,* was exhibited and published as a book to raise funds for the French relief agency Medicins Sans Frontieres, and together with overwhelming evidence from other film sources, helped to belatedly force the attention and the response of the Western world on the devastation of famine in the Sahel. The photographs are direct and unsparing evidence, epic like the disaster itself, and form a biblical narrative like the fulfillment of a prophecy of doom.

Whereas Salgado's images can be seen as the apocalyptic result of man's continual destruction of the environment, David Goldblatt has repeatedly stated that his photographs, which foreshadow the climactic collapse of an isolated society, serve simply to record. Through the crisis of apartheid that spans the years of Goldblatt's adulthood, his work is cumulative, following his intimacy with the Afrikaner farmers, the black miners, the townspeople of Soweto, or the white suburb of Boksburg, through more than twenty years of persistent, probing observation.

Neither intervention nor documentation are adequate ends for Susan Meiselas, who is well known for her photographs in Latin America, and here presents recent work photographed during the Philippine revolution. Wary of the very nature of the highly dramatic color photographs she produces, and the "theater of war" effect they create for the viewer, Meiselas is now attempting to describe a far more questioning, conscious sense of history, looking for images as close as possible to the intensity of the reality she has experienced.

These images and accompanying texts carry us beyond the numbing effect of the seemingly endless, quickly captured, journalistic stories that fill magazines, newspapers and television. The gap between reality as it is, and the truth as presented by the media, is narrowed. We begin to feel with these photographers the extent and immediacy of crisis; and to intensify our own engagement as witnesses.

THE EDITORS

Sebastião Salgado: Man in Distress

By William Shawcross and Francis Hodgson

A thing of beauty is not a joy forever. That is the major problem that confronts viewers of Sebastião Salgado's extraordinary photographs of famine in the Sahel.

Here in this issue of *Aperture* are photographs, beautiful many of them, of the utter despair and degradation in which a vast part of humanity lives. They were taken in the Sahel—Sudan, Mali, Ethiopia—at the height of the famine of 1984–85. That is to say, they were taken during those brief weeks when suddenly that famine seared itself across Western conscience and famine relief became an event, almost a fashion.

Salgado went to the Sahel on behalf of the French aid group Médecins sans Frontières. This is a small organization by comparison with, say, CARE, but it is probably the most important overseas-aid organization in France. It is also politically contentious: in 1985 it was expelled from Ethiopia for denouncing the regime's policy of resettling peasants from the north of the country in the supposedly more fertile south. Other aid organizations in Ethiopia were also troubled by this policy—for much of it was carried out under duress—but MSF was the only one to speak out against it.

This is a constant dilemma for relief agencies: all too often they are in a country whose policies are exacerbating rather than alleviating the conditions that the agencies are seeking to cure. What to do? Speak out against them and so risk expulsion, or stay quiet and contribute what health they can on the margin?

Salgado's photographs were published as a book in France and were a great commercial success, raising considerable sums of money for MSF. The book, like the photographs themselves, is beautifully produced, but it is a little too scary for a coffee table. It's the same problem—beauty and misery locked inextricably in the eye of the beholder.

Salgado presents his photographs as a documentary, almost a narrative of the catastrophe that has hit the region and which continues still today, long after Western attention, fickle as ever, has flickered away. Indeed, perhaps the most important thing to remember while looking at such photographs is that famine today continues almost as grim as when Salgado was there.

There have always been hells on earth, and by now photog-

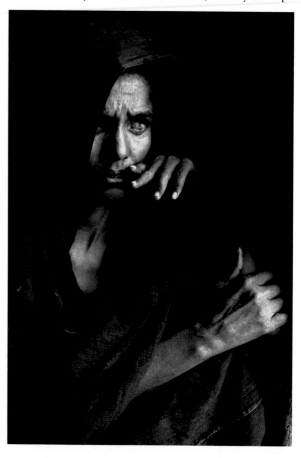

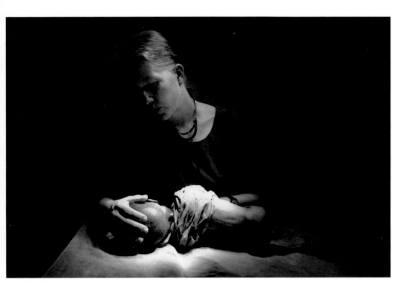 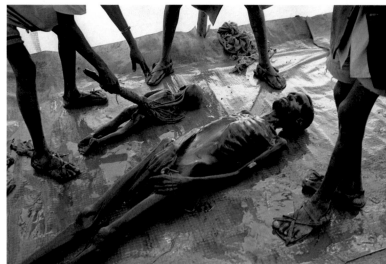

raphers have been transporting brief glimpses of them for over a hundred forty years. One of the earliest such pictures was Roger Fenton's 1855 photograph from the Crimean War, "The Valley of the Shadow of Death." This managed to convey the full horror of standing under concentrated artillery fire, without showing a single human figure—just cannonballs and tracks. Consider the piles of corpses being shoveled aside at Buchenwald. Or the little girl, Kim Phuc, running down the road in Vietnam, her napalmed skin hanging in tatters from her little frame.

Salgado's photographs contain a very disconcerting blend of beauty and horror. No doubt this is deliberate. Salgado has been photographing catastrophes for many years and knows well that we have inbuilt systems to protect ourselves from horror. At their best, press photographs still do shock. Kim Phuc certainly shocked us all. But Salgado forces us, by offering great beauty as well, to pay more attention, to be truly awestruck.

Take, for example, the photograph of a group of people walking into a uniformly gray, empty future (pages 6-7). Two groups of three figures trudge with heads bowed. Only one figure is looking back. Each half of the composition is dominated by drapery. Folds of cloth drag behind the starving people, who have no possessions at all except for a pathetically scant water skin half hidden by the naked child who holds his hand over his eyes.

Many of Salgado's pictures seem to be placed in the long Christian tradition of the iconography of suffering. It is not farfetched to see overtones of the Descent from the Cross in Salgado's photograph of the patient undergoing surgery (page 4, right). The expensive, Western medical equipment forms an extraordinary contrast with the medieval torment of his other pictures. But there is more to it than that. At least in the Chris-

tian tradition, suffering depicted in the pose of arms so far outstretched contains hope. It is a latent reference: it does not need to be stated.

Consider also the photograph of the grieving woman (page 2). Salgado has managed to obtain extraordinarily detailed texture in very low levels of light. The black around the woman is complete, a black that allows no gleam of light. It creeps under her hood and into her clothes, besieging her or weighing her down. And the savage irony of the gleam of light in a sightless eye is horrifying. But again, in the Christian tradition, this is no mere anonymous woman; she is a Madonna, her suffering standing for the suffering of all others.

Look at the picture of Dr. Dorothee Fischer (page 3, left): the precise documentary content is intertwined with the complex mythological one of tending a child doomed to suffer. Other pictures give us a feeling of exodus, whole nations on the move in search of help. Again, perhaps it is not too farfetched to associate this with an earlier exodus, which ultimately brought salvation to those on the journey. The landscape through which they trudge is one that every schoolchild can associate with the Holy Land: sandy, stony, with no vegetation, assaulted by a relentless sun that has sucked away all moisture. To recognize such a landscape does not necessarily help us to understand what is going on within it, but it does make it possible for us to look again, freed from the protective reflex "This is another world." It is not. It is a familiar world, part of the Judaeo-Christian tradition. By placing the Sahel within a tradition we know, Salgado refuses to allow us to claim distance or strangeness as a reason for not understanding.

Salgado's photographic representations of the love and honor that go into preparing pitifully diminished corpses for eternity (page 3, right; page 4, left) are not macabre. In the Sahel dignity

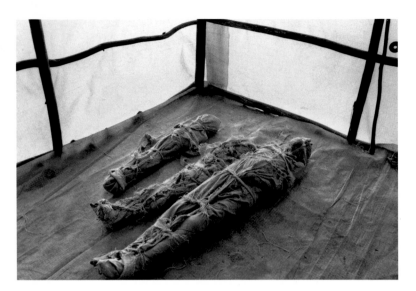 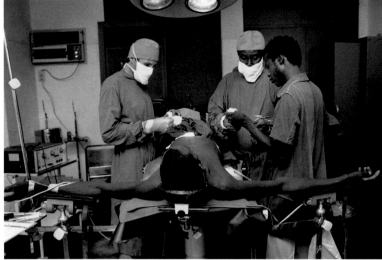

in death is almost the only possession that many people have left to them. Salgado's representations of the way in which they are laid to rest (often in sacks that contained the grain sent to save them) remind one of the very similar carvings that were common on funerary monuments in late medieval Europe; they insist that the viewer remember his humility.

Thus Salgado's photographs are more than the cold docketing of disaster. By using images that recall others long familiar to us, he forces us to contemplate seriously what we see. He allows us to bridge the abysmal gap between the unimaginable (but very real) and ourselves by interposing photographs that ask for reaction from the eyes first and only then from the conscience.

There is another purpose that such photographs may serve. Unlike news pictures, which tend, with some exceptions, to be ephemeral, they have a lasting quality. This is terribly important because of that very fickleness of Western attention that we mentioned above. The exiled Czech writer Milan Kundera wrote in *The Book of Laughter and Forgetting*:

> *The bloody massacre in Bangladesh quickly covered the memory of the Russian invasion of Czechoslovakia; the assassination of Allende drowned out the groans of Bangladesh; the war in the Sinai made people forget Allende; the Cambodian massacre made people forget Sinai; and so on and so forth, until ultimately everyone lets everything be forgotten.*

Exploring another, related paradox, George Steiner wondered about the "time relation" of events in his book *Language and Silence*. He pointed out that while Jews were being murdered in Treblinka, "the overwhelming plurality of human beings, two miles away on Polish farms, 5,000 miles away in New York, were sleeping or eating or going to a film or making love or worrying about the dentist." Steiner found these orders of simultaneous experience so upsetting that he puzzled over time. "Are there, as science fiction and Gnostic speculation imply, different species of time in the same world, 'good times' and enveloping folds of inhuman time in which men fall into the slow hands of living damnation?"

Humanitarian aid is essential. It is often required because of abject political failure. It is neither intended, nor is it able, to resolve political crises that governments or political movements have created. But too often nowadays governments actually exploit humanitarianism and use it as a fig leaf to conceal either the poverty or the ruthlessness of their policies. In Biafra, in Cyprus, in Angola, in Cambodia, in the Sahel, humanitarianism has been used to prolong war or to perpetuate man-made agonies.

At the end of 1986 the French Minister for Human Rights, Claude Malhuret (who used to be president of Médecins sans Frontières), spoke of a new policy of the Ethiopian government, called Villagization. This involves shifting thirty-three million people out of their traditional hamlets into what are in effect "strategic hamlets" controlled by the party and the army. Malhuret said that the rest of the world will be paying for this policy three times: first in development; then in famine relief, because the peasants will have little chance of getting decent harvest from their new fields; and third in refugee relief, because so many of them will flee to the Sudan.

Salgado's photographs are not a historical record; they are of the present, and they are of the future. Their message is that humanitarianism is not enough.

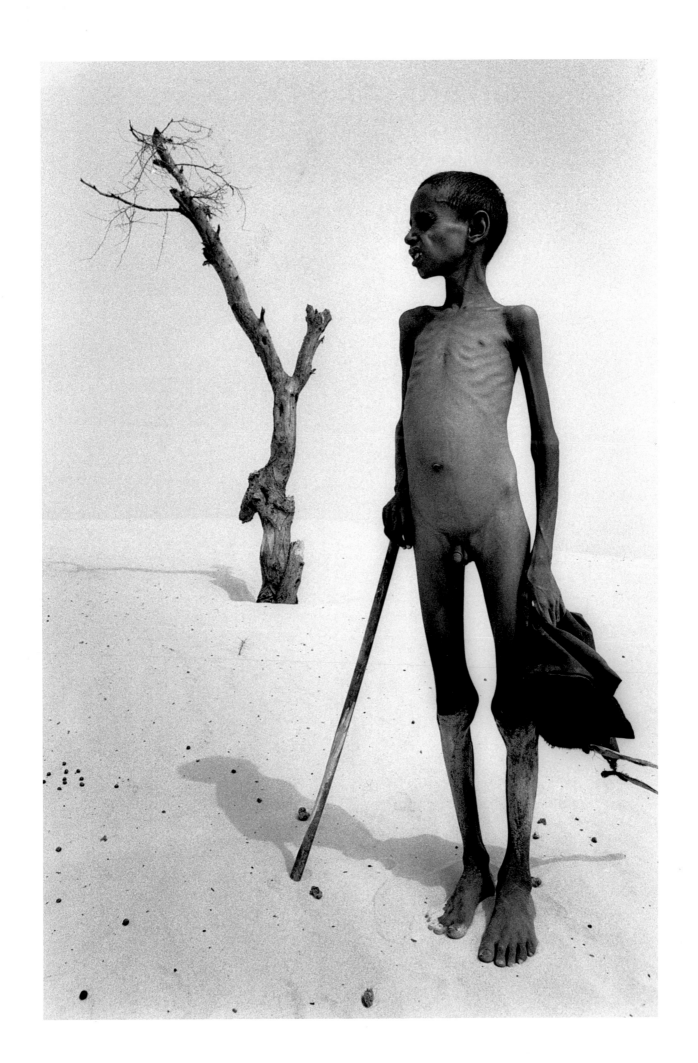

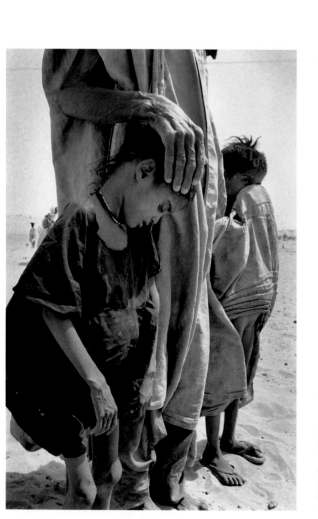
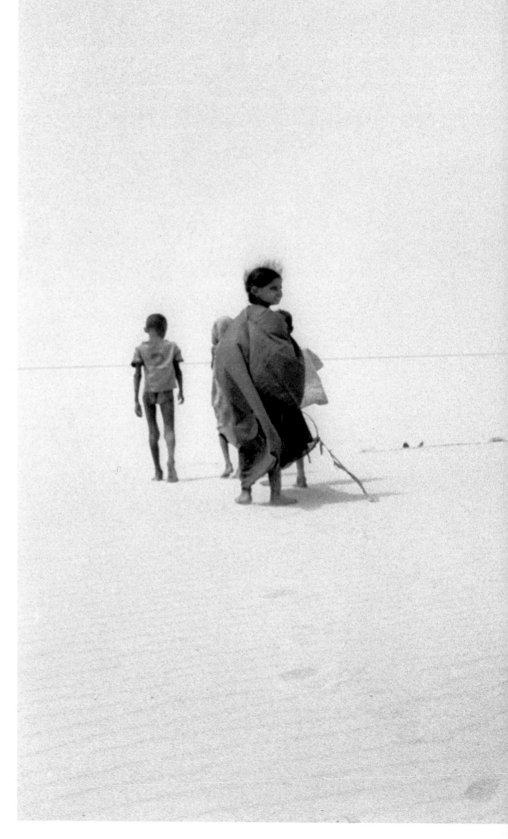

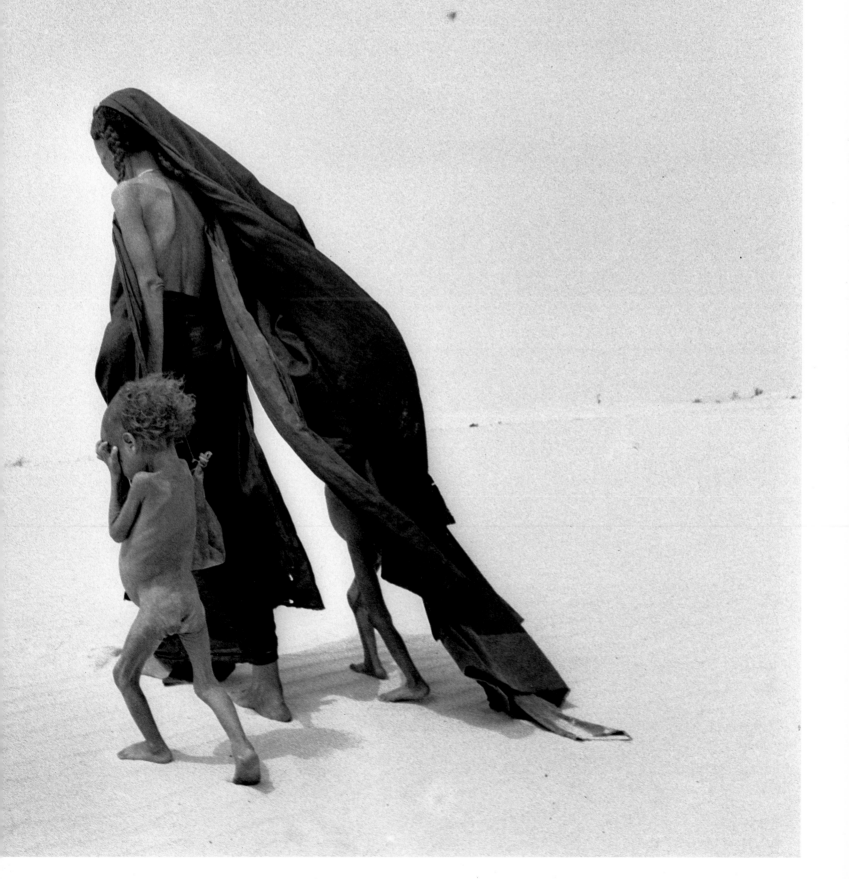

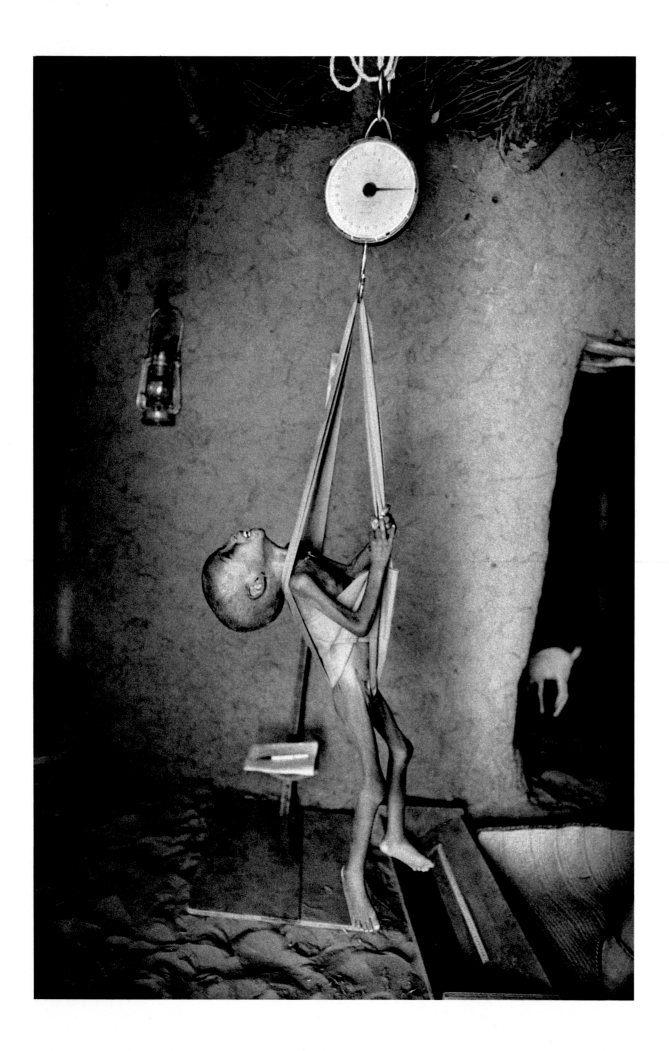

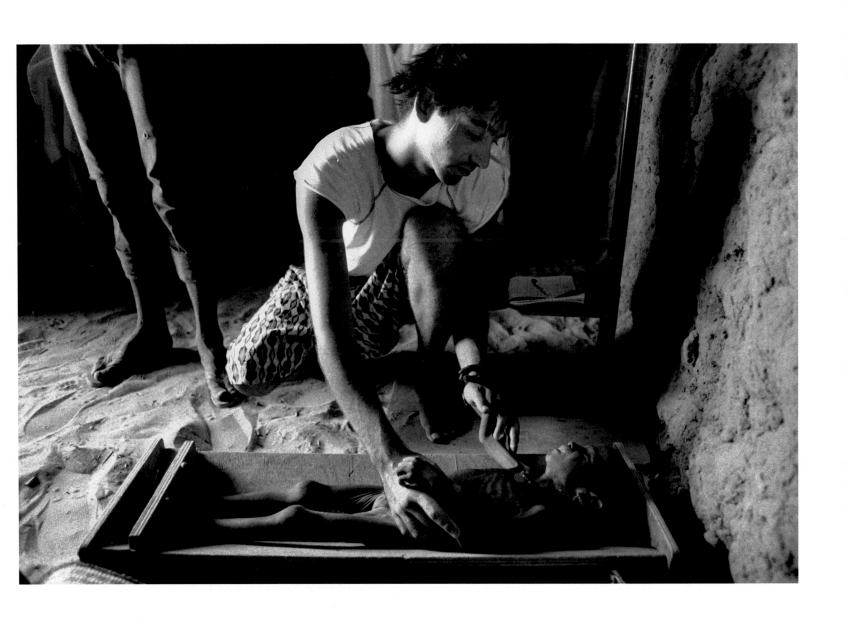

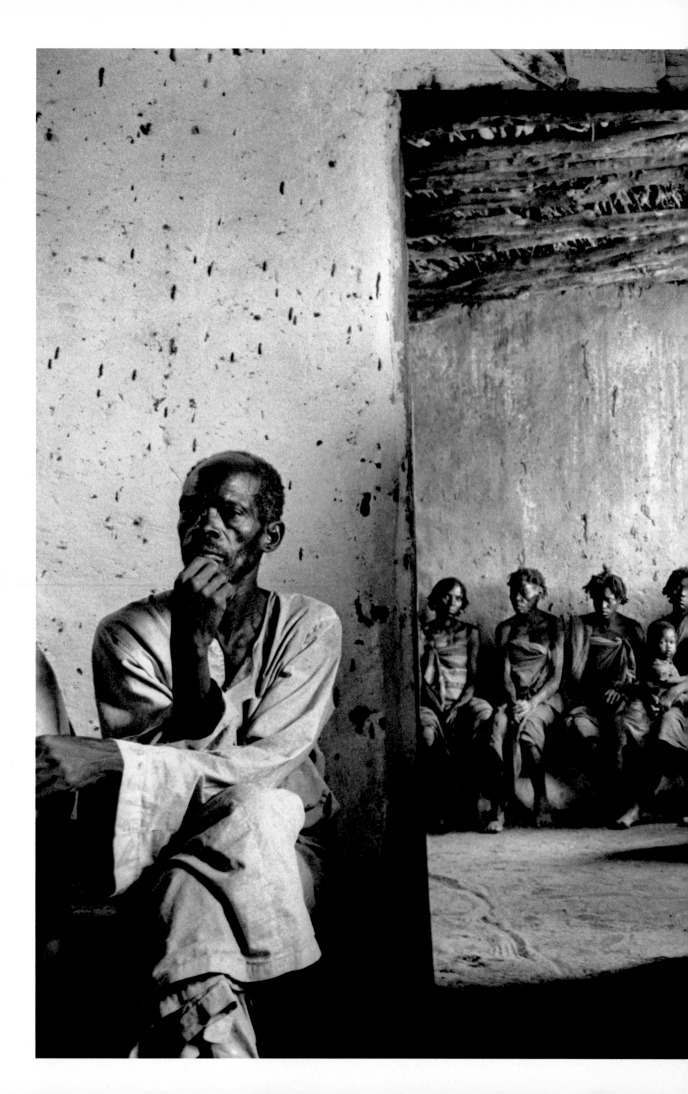

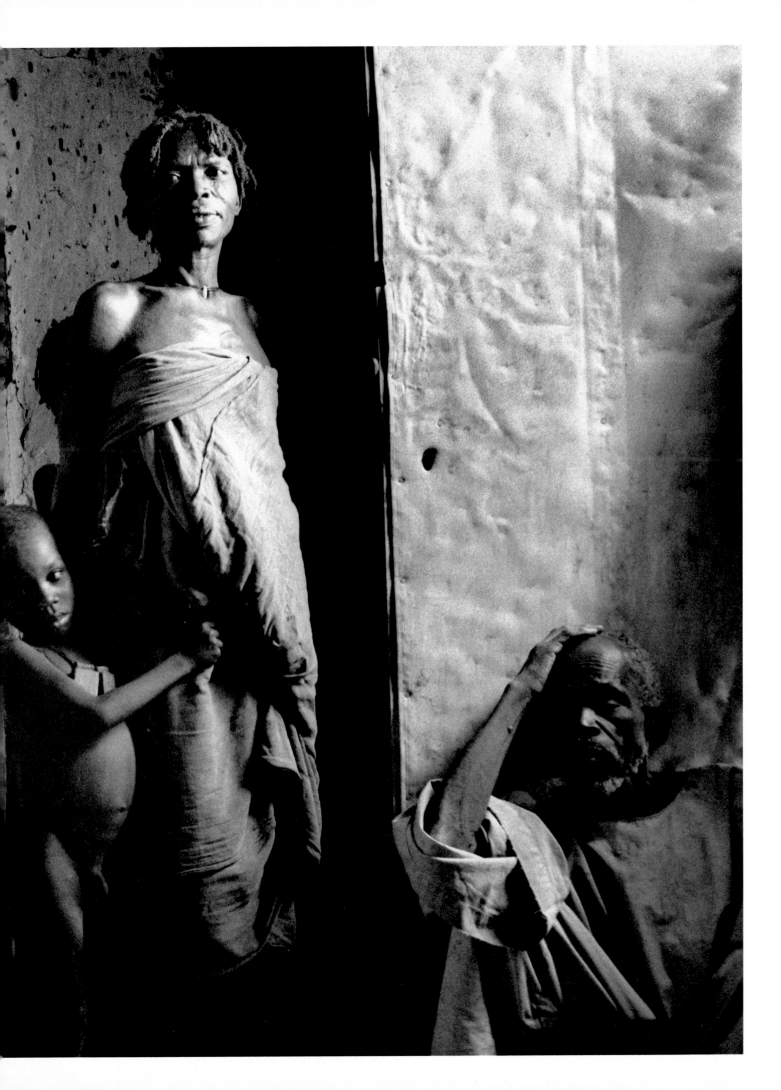

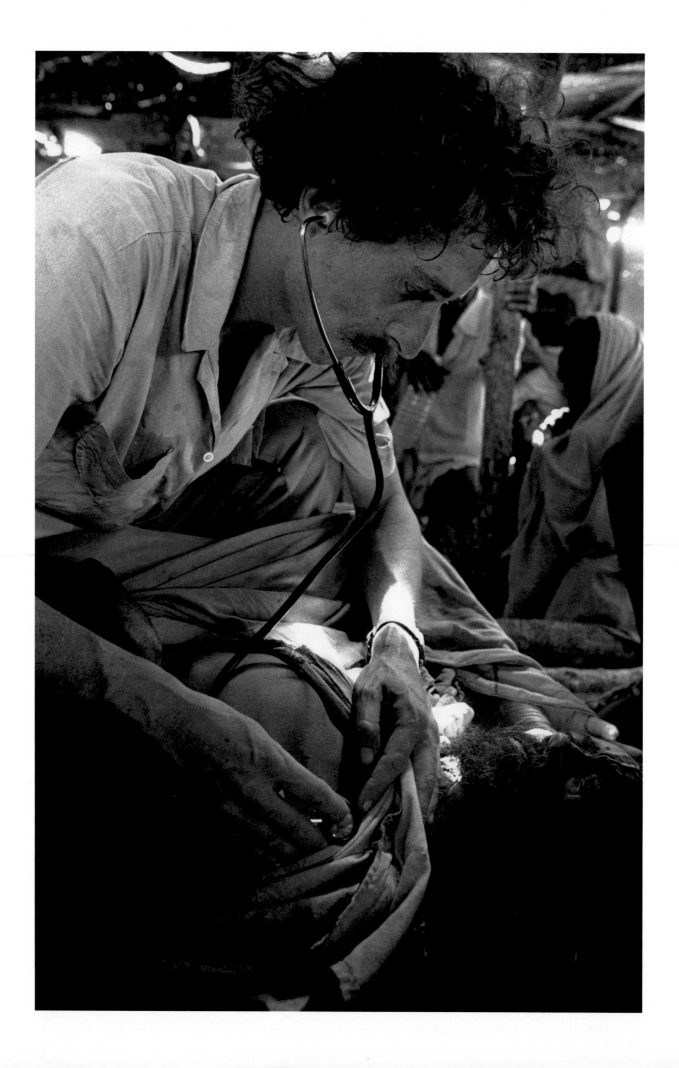

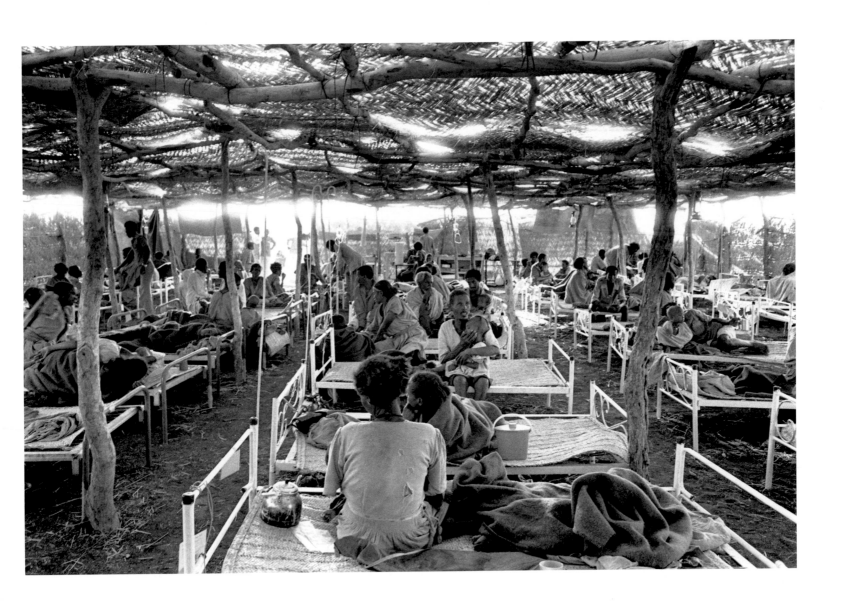

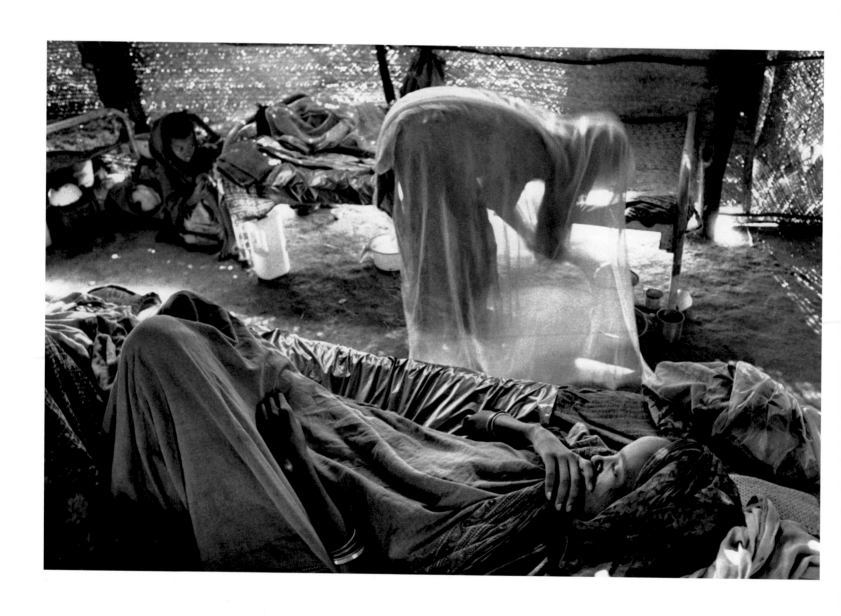

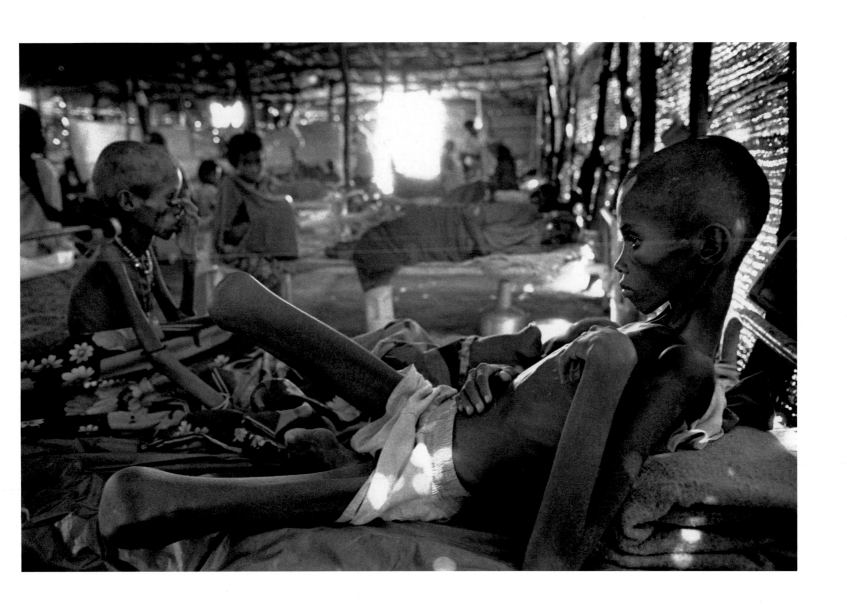

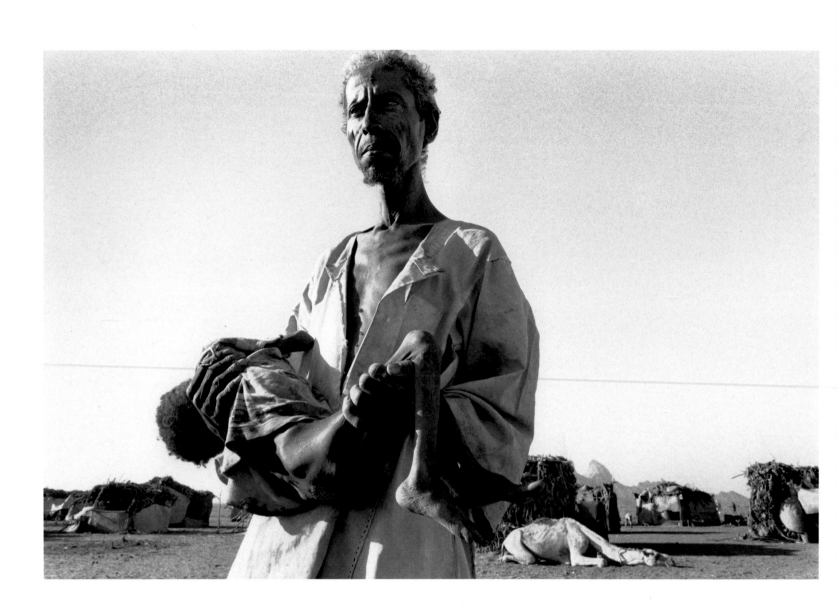

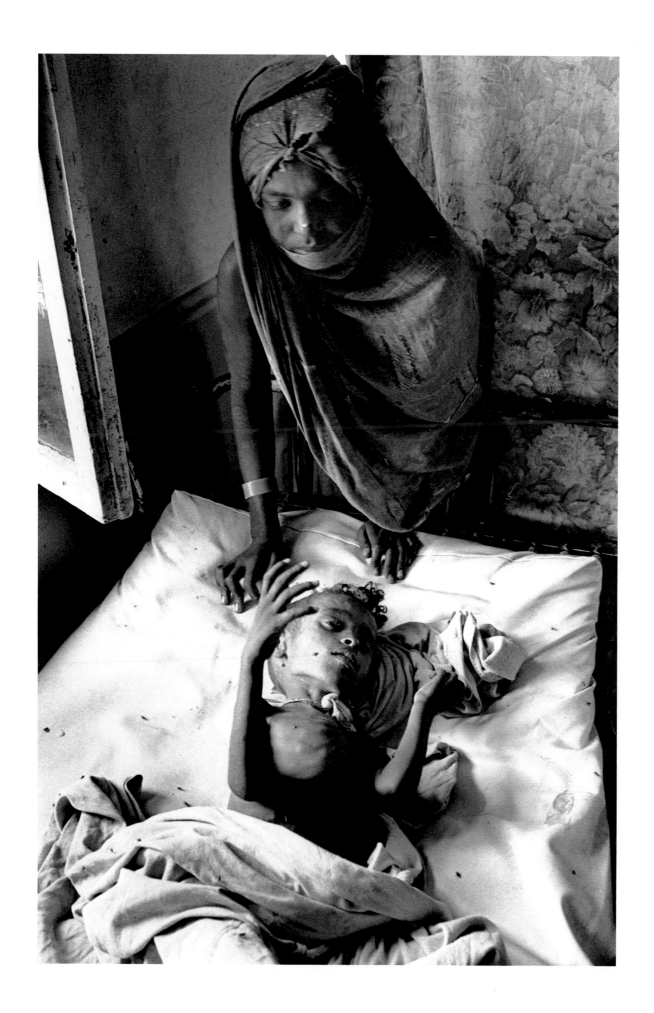

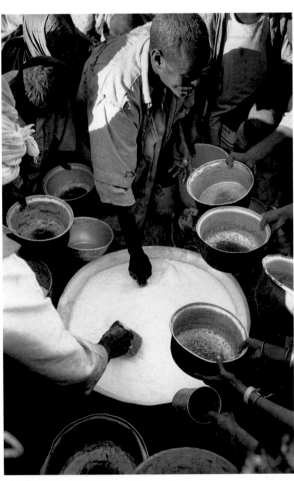
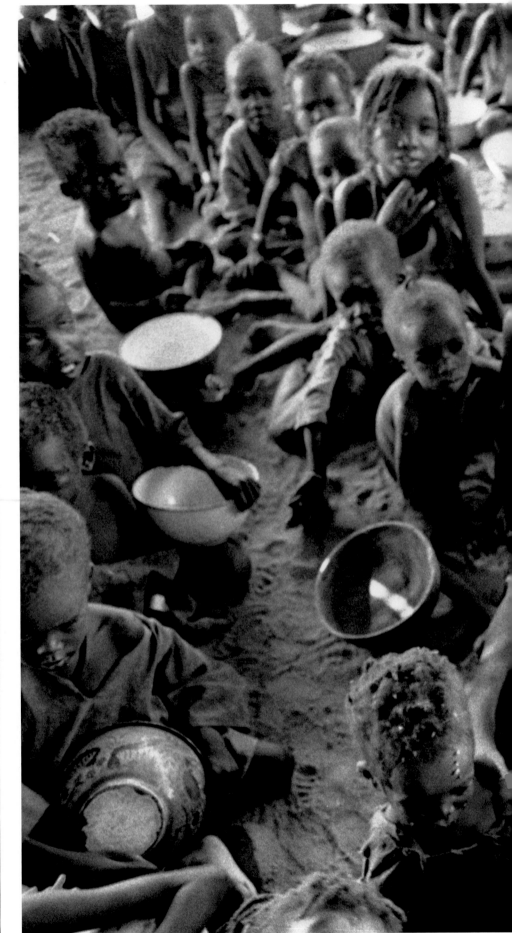

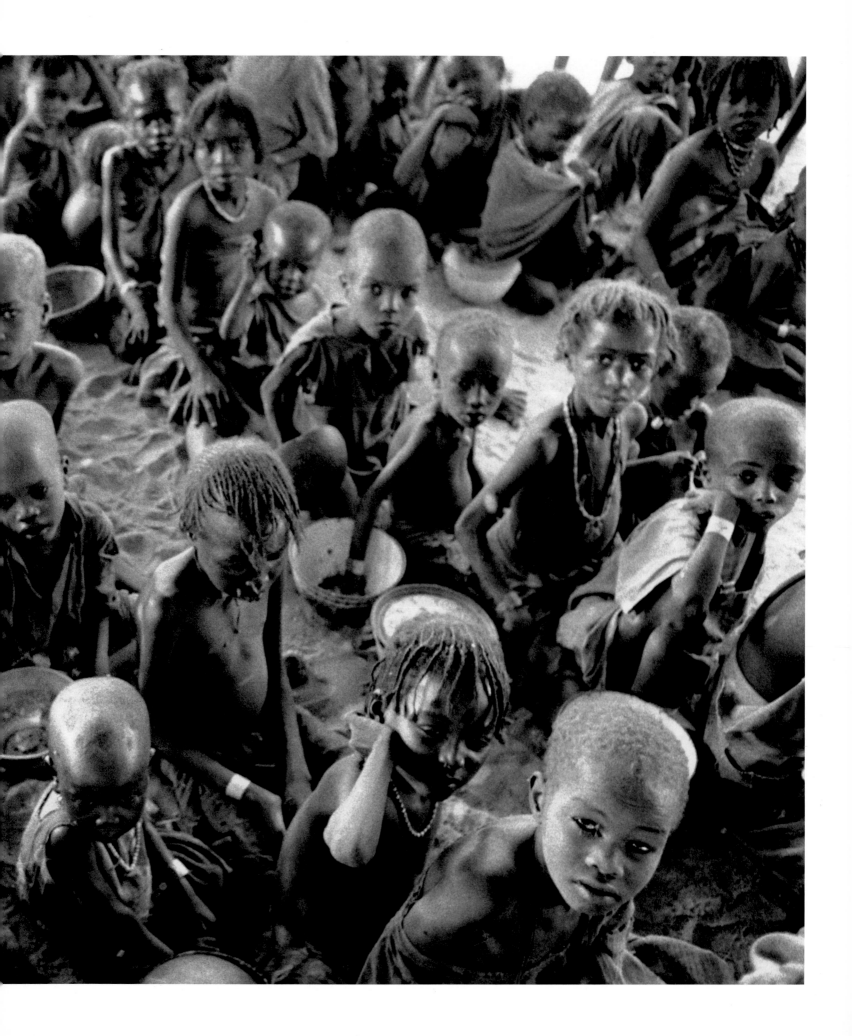

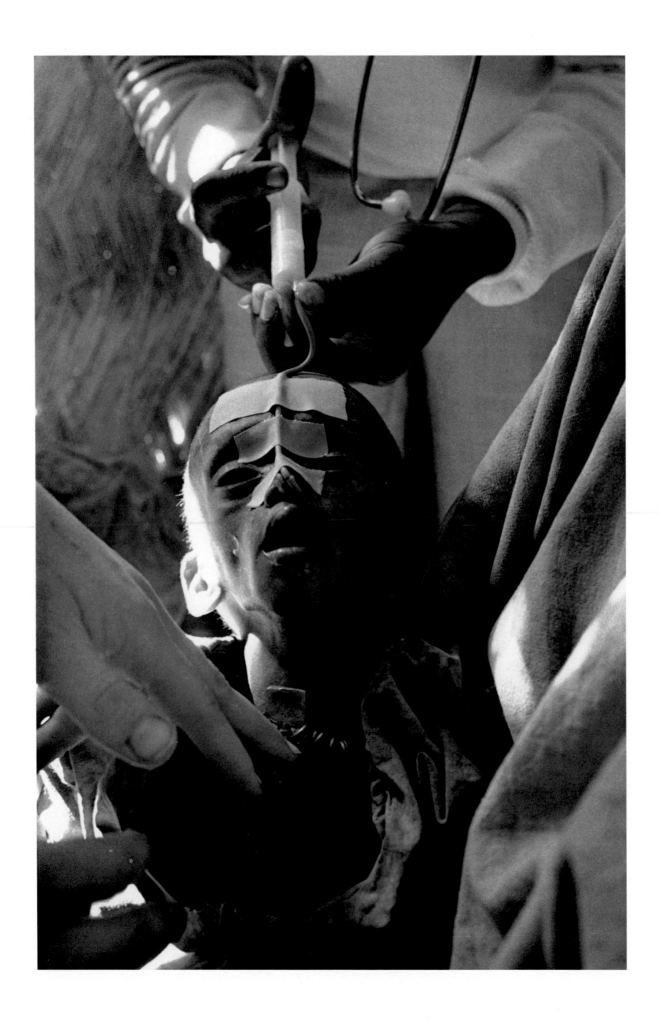

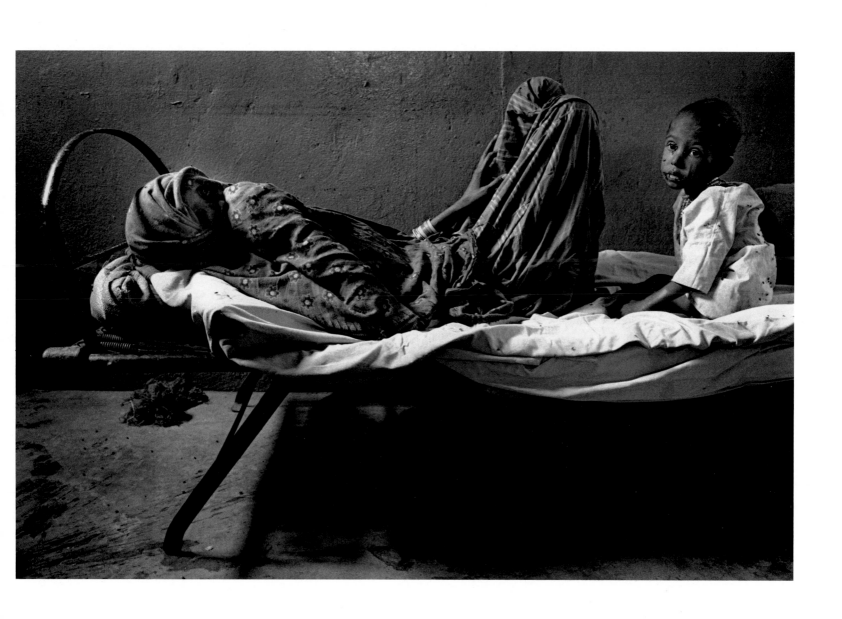

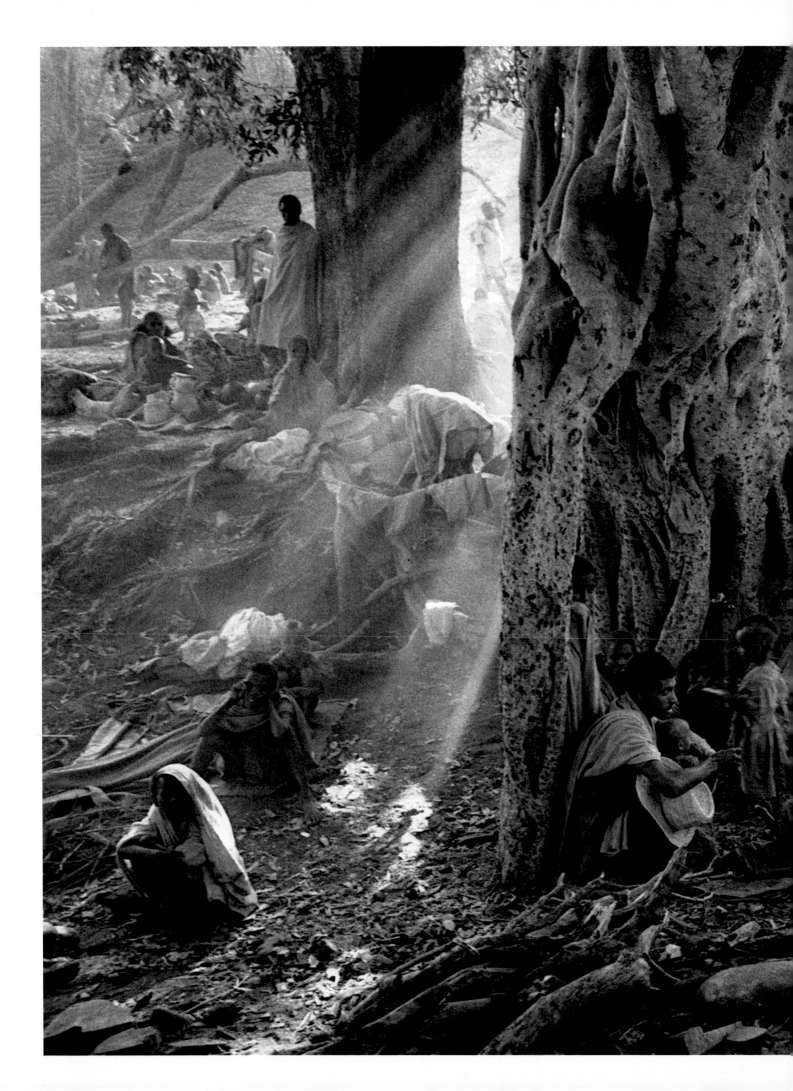

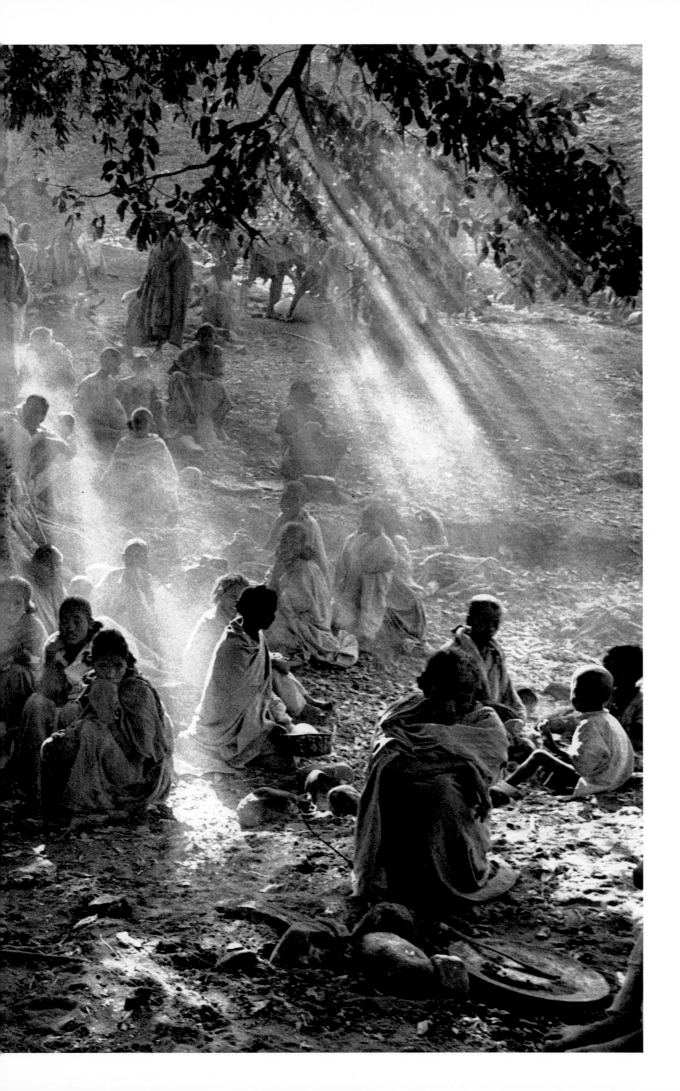

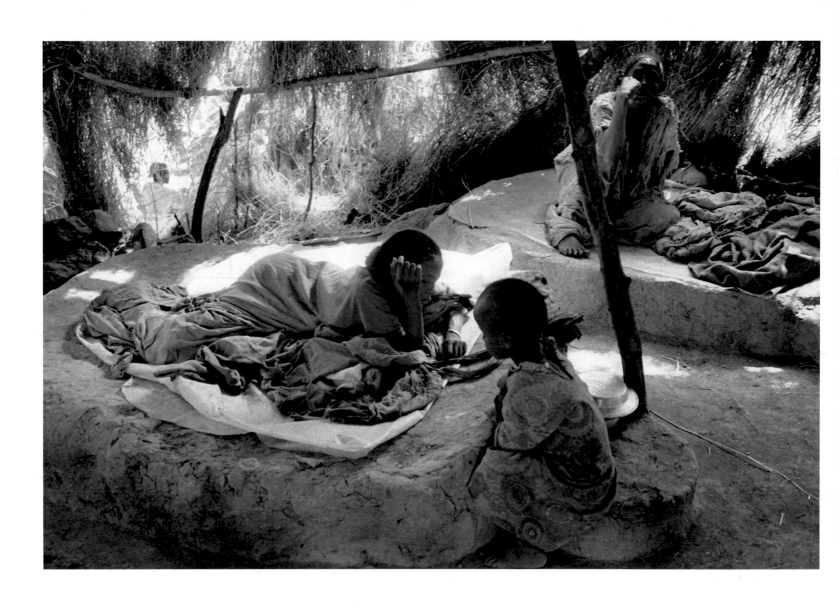

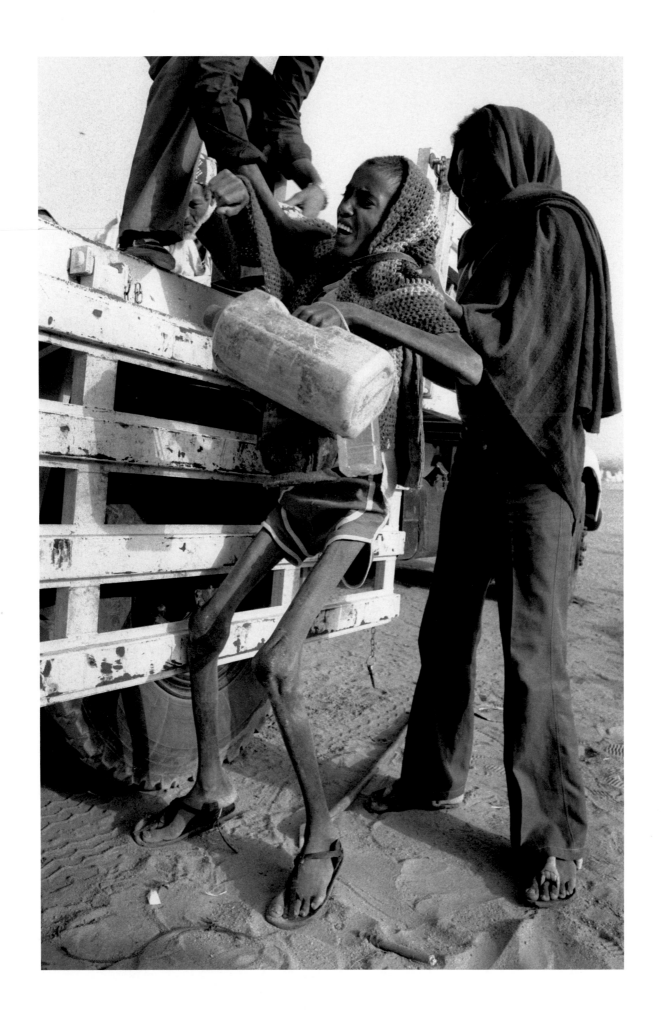

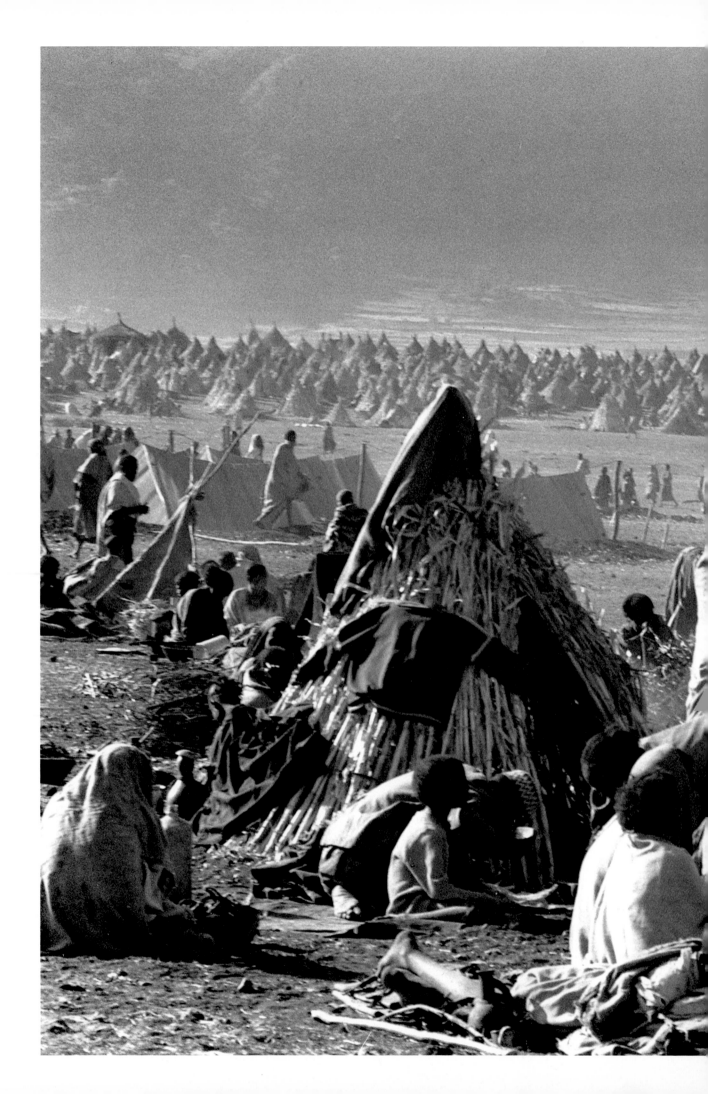

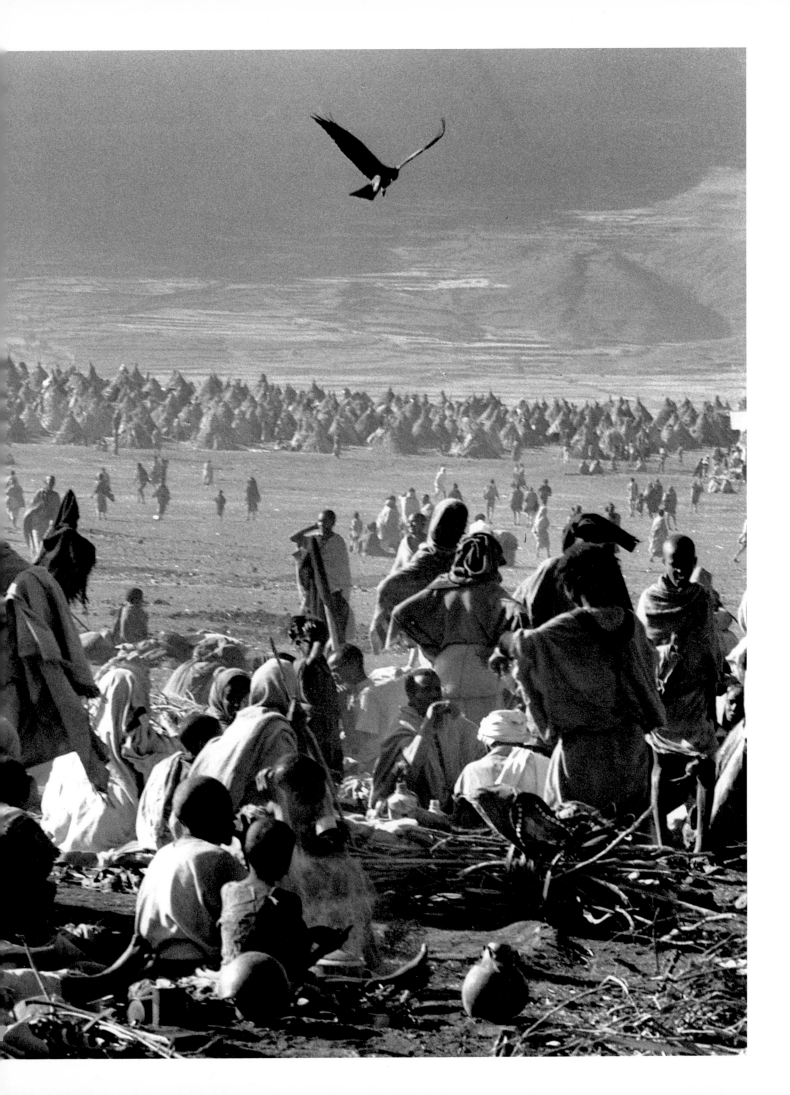

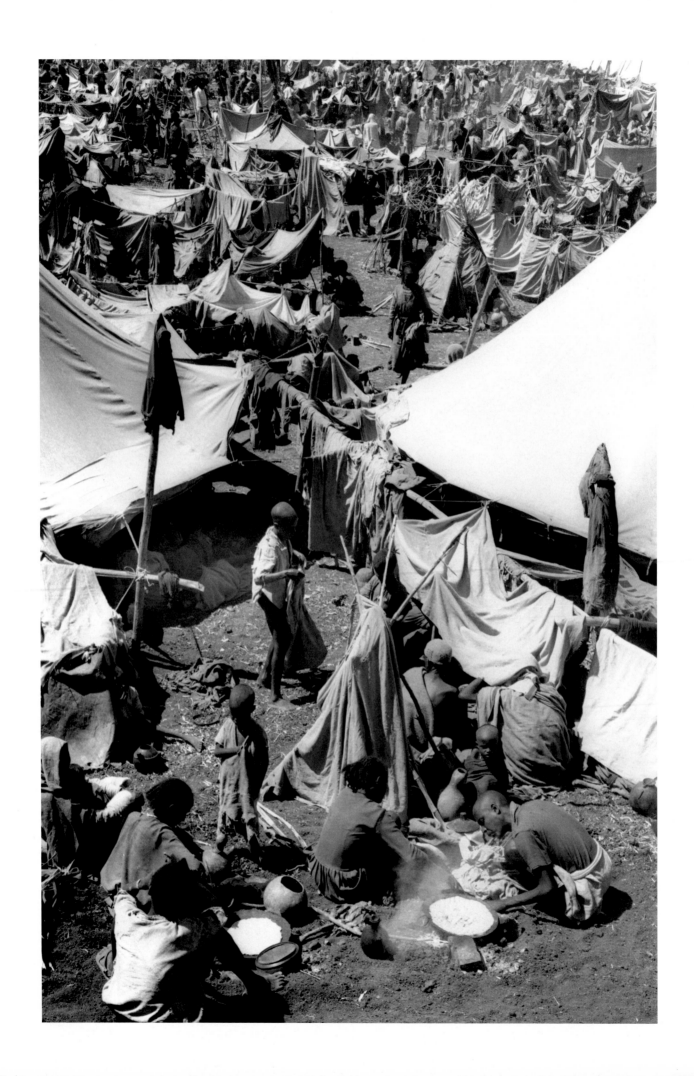

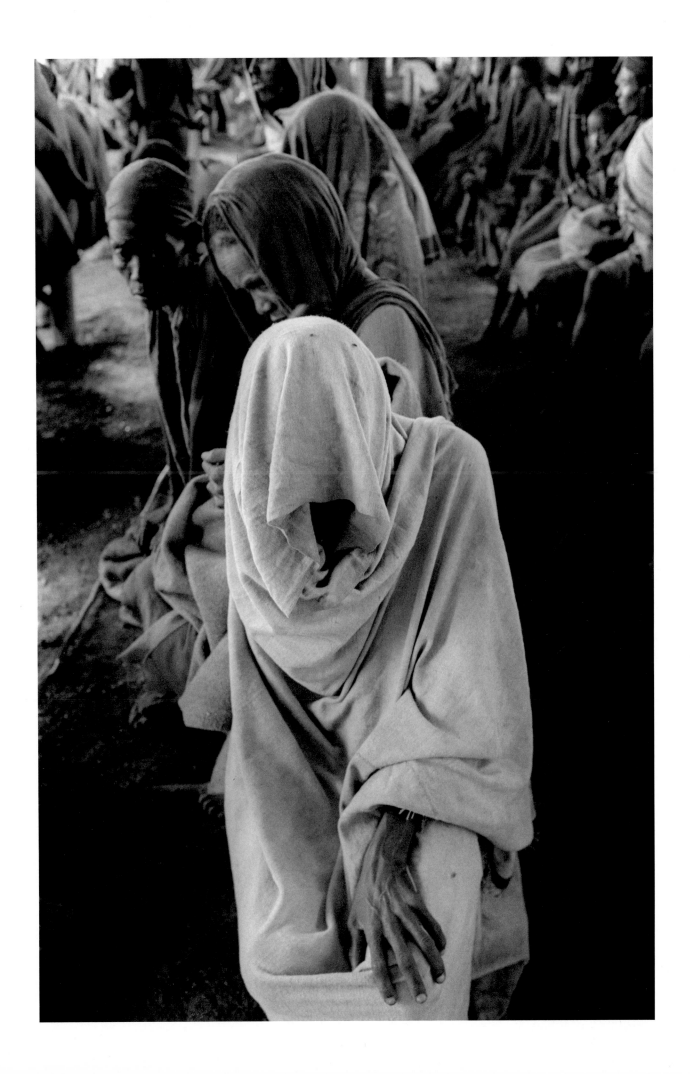

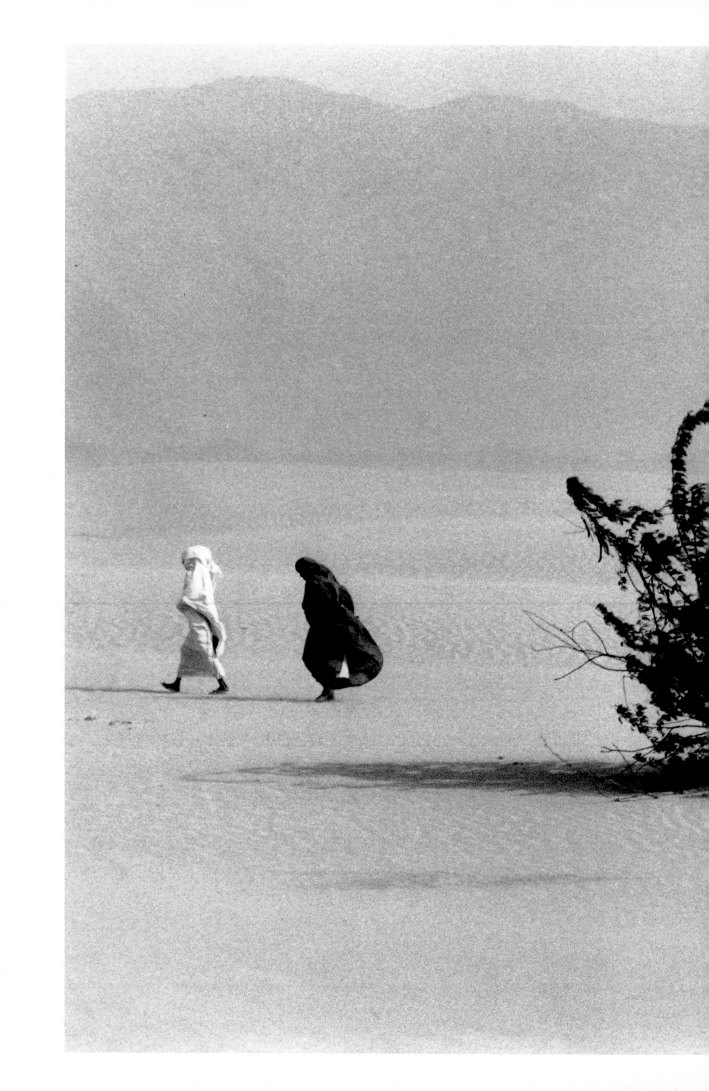

Susan Meiselas: The Frailty of the Frame, Work in Progress

A Conversation with Fred Ritchin

THE NEW YORK TIMES, THURSDAY, OCTOBER 23, 1986

6 Civilians Killed by Mine in Nicaragua

By JAMES LeMOYNE
Special to The New York Times

JINOTEGA, Nicaragua, Oct. 21 — At least 6 civilians were killed and 30 seriously wounded Monday when their crowded civilian transport truck ran over a powerful land mine north of here, according to several wounded passengers and doctors at the scene.

The attack was the second major civilian disaster in recent months caused by a land mine that area residents believe was planted by United States backed guerrillas. A rebel official denied that the guerrillas had planted the mine.

The mine blew through the bottom of the village's daily civilian transport truck, hurling peasant passengers in all directions, according to 10 witnesses who were in the truck or involved in rescue efforts.

"There was blood, personal belongings and other effects scattered everywhere," said Dr. Maj G. Stormogipson, a Presbyterian church volunteer doctor who works in the region and who rushed to the scene to treat survivors.

Most of those hit by the blast were rushed to the main military clinic near here and to the local hospital in Jinotega, where they filled the bare medical cots with scenes of suffering.

All of the wounded are civilians, according to hospital records and survivors.

They said four of the wounded were children between 6 months and 13 years of age. A pregnant woman and several peasants over 60 are also among the victims, as are two local evangelical pastors, one of whom was reported killed. The other lost his leg.

A powerful mine killed 34 peasants in July in the same northern region.

The mine Monday cut a yard-deep hole in the hard gravel highway one mile south of the village of Pantasma in an area where there has been heavy fighting between rebels, known as contras, and Government soldiers.

The use of land mines by the rebels and attacks on largely civilian targets such as peasant farm cooperatives have become issues in the growing war financed by the United States Government. Congress recently authorized the release of $100 million in new military aid to the rebels.

In the past, rebel officials have said that they mine some roads used by military transports and that civilians should not use the routes. Critics of the rebels say they do not make enough of an effort to avoid civilian targets.

A senior rebel official denied today that the rebels were responsible for the blast Monday. "It's not in our interest to terrorize the peasantry," the rebel official, Luis Somarriba, said in a telephone interview.

According to six passengers on the destroyed truck, the vehicle was a bright yellow, clearly marked civilian transport of the type commonly used for bus service in remote villages with poor roads.

Mr. Somarriba, one of the top four officials of the United Nicaraguan Opposition, a rebel organization, denied that the rebels had such powerful land mines.

Several Sandinista military transports have been destroyed in recent months in this region. It seems unlikely that the Sandinistas would blow up their own army vehicles.

The Government made little effort to publicize the blast, getting in touch with only a few foreign reporters.

This reporter was not reached by the Government and was not permitted to enter the local military hospital to see some of the victims. The reporter was asked to leave the civilian hospital where most of the wounded were being treated, and this hospital was then closed to all reporters.

Susan Meiselas went to photograph for five weeks in the Philippines in 1985–86 and stayed for five months. During that time Cory Aquino took power and Ferdinand Marcos fled the country. Since 1978, when she first went to cover the incipient Sandinista revolution, Meiselas has been primarily photographing in Central America, particularly Nicaragua. Her book Nicaragua *was published in 1981.*

SM: . . . Imagine this very small room where there are no windows and it's precisely the correct proportion so that when people enter they feel an intimacy. And, if there are eleven portraits on the walls of the Nicaraguans who had limbs amputated because of one land mine and they look back at the people who walk past and each hears the others' voices, would it become merely fashionable art—a concept piece? What do you do when there are no magazines willing to publish your work, no pages to be turned—at least there still are walls. . . . It's a strange place to be, to be so unaccepting of journalistic process because it seems so ineffective at the same time that I have to believe in it in order to work. That is a long way from where I began.

FR: Describe the distance that you've come. You started working in Nicaragua in 1978, and on the book *Carnival Strippers* before that.

SM: As a documentary photographer, walking, turning a corner, it has always been my own curiosity leading me to a place and the possibility of a relationship with people. With *Carnival Strippers*, I became involved with a place and people that many people had passed but somehow not focused on, and it became a part of my life for three years because of my own fascination and no one else's. Trying to make shape of it, a sense of urgency for me was only in terms of wanting to make the women's voices visible. Then, beginning in the same way to go to Central America, I found myself in the middle of the eye of a hurricane and had to learn what the media is about—the manner in which it defines the world, allows it to exist or not to exist based on the media's own interests. So that whether it's a news crew or photographer or journalist, an event doesn't exist in our world unless one of us happens to be there. Then the weight of that accident dictates so much in terms of the eventual survival of

Nicaragua . . .

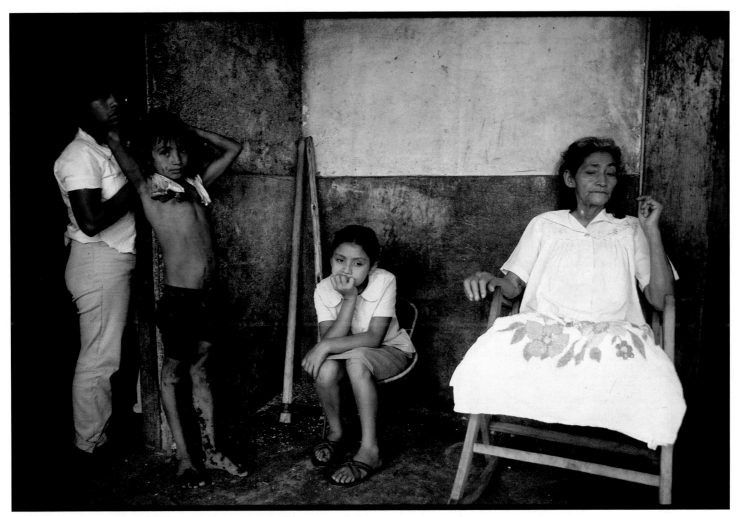

Francisca Zelaya, amputee from landmine outside Pantasma, in northern Nicaragua

those whose lives we report, to the point that when the Sandinistas take power, their own existence continues to be threatened based on our definition of them through images and text. It is frustrating to watch myself becoming part of that battle, to be inevitably placed within the crossfire of that process.

FR: So what you're saying is that your image-making was originally productive in Nicaragua because it brought something important to people's attention, not just to satisfy their curiosity but in a helpful, tactical, political way. But then when you brought back the pictures the place became besieged and everybody used it for their own purposes and had their own sense of it. Soon you've lost control and even lost the ability to stay in the discussion because it's been taken over.

SM: Yes, it's difficult now to feel that I can't make an image to bring the devastation of the war with the contras home, even though I feel a tremendous urgency all the time to do so. It's not that there haven't been images made, but the larger sense of an "image" has been defined elsewhere—in Washington, and in the press, by the powers that be. I can't, we can't, somehow reframe it. . . . The Congressional vote for one hundred million to the contras led me back to Nicaragua this past summer but I felt that every time I lifted my camera to frame I was acknowledging death or anticipating it. So whether it was a building that could be bombed or a person who would no longer be, everything I framed suddenly had a sense of vulnerability, frailty, temporariness—to frame anything would just lead to the inevitable death. I didn't want to even raise my camera.

(continued on page 41)

Philippines . . .

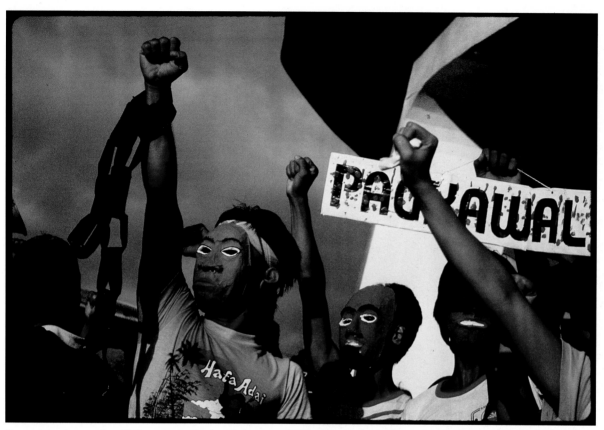

Demonstration against U.S. presence in the Philippines, held in front of Clark Air Force Base

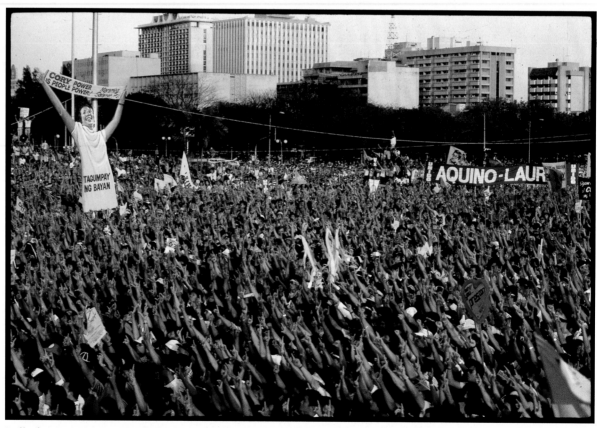

Rally for Cory Aquino just before President Ferdinand Marcos left the country, Manila

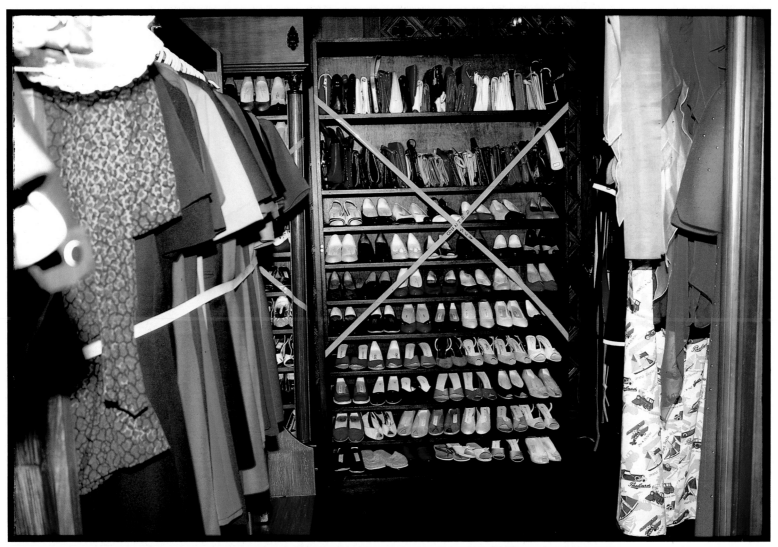

Imelda's closet, National Palace, the day after the Marcoses fled

Marcos's Antiriot strike force in position, Manila

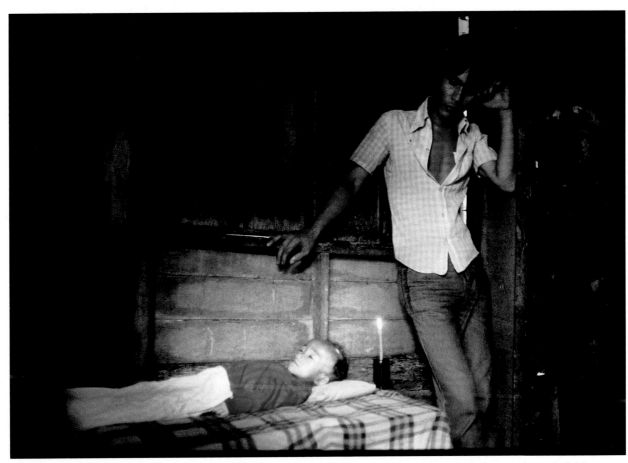

Rodolfo Sarsaba with body of his two-year-old son who died of malnutrition in a slum in the town of Bacolod, Negros

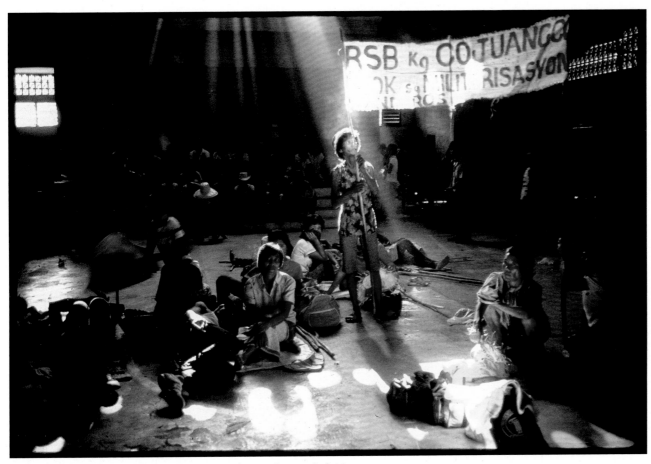

Peasants waiting to begin human rights march outside Bacolod, Negros

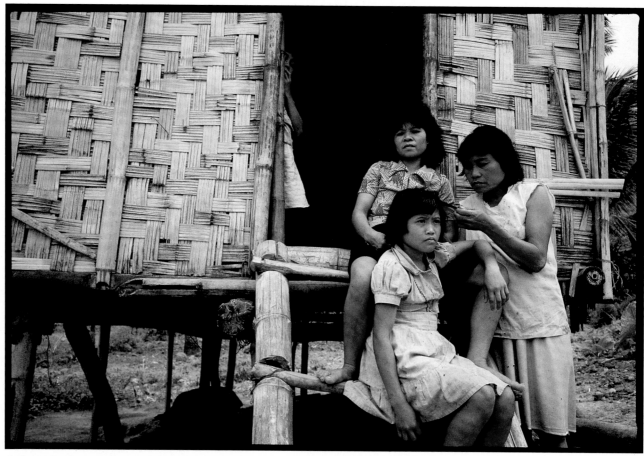

At home in the mountains of Negros

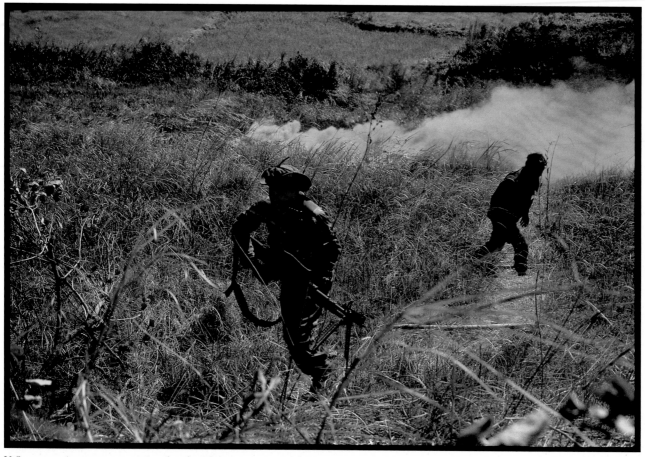

U.S. counterinsurgency training for the Philippines special forces

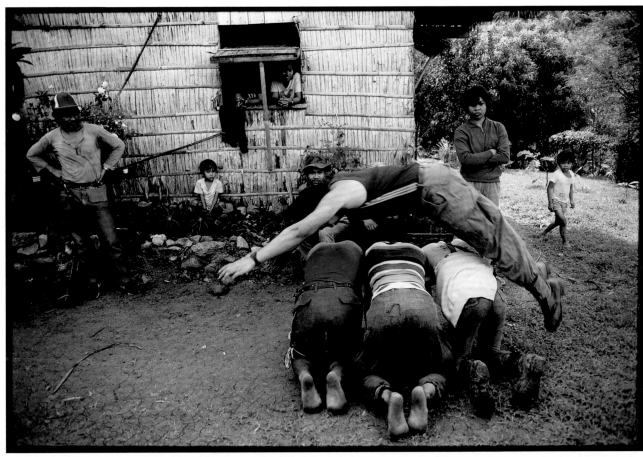

The New People's Army, an antigovernment force, training in Negros

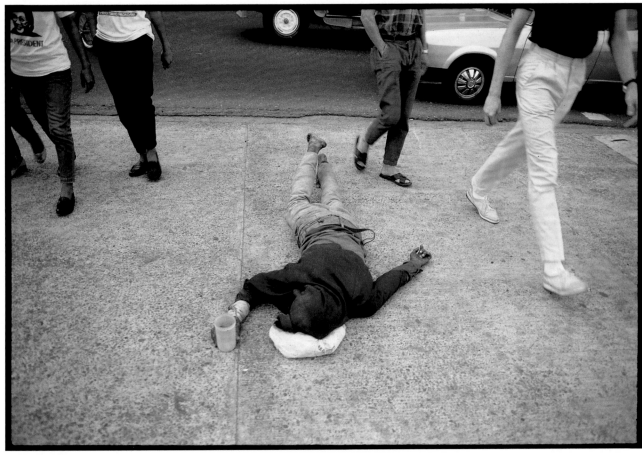

Streets of Manila

Store window in downtown Manila

In the movie *Hearts and Minds,* a Vietnamese peasant who is showing the remains of his home to the filmmaker is saying, "First the Americans bomb us and then they come and photograph us." I didn't want to be that American—the outsider who can come and go, come with the invading troops or be there when they arrive. I had dreams of waking up and watching the U.S. paratroopers land not knowing where I would go. I don't know that I want to photograph that nightmare, nor make my experience theater for everyone else.

That's what I felt. I also felt—I should do this very factually without any feeling and really render Managua because it might not be here in six months. It wasn't from a commercial sensibility that I thought it would be valuable to have these images. It was with the sense of being somewhere between a scientist and an anthropologist rendering a culture that once was. That was the feeling, and it paralyzed me.

The images I made in the Philippines are fragments of moments that in many ways are symbolic for me and may not read easily for the viewer. Somehow the cross of tape across Imelda's shoes says it all for me. It's as though I've gotten to the point of almost talking in shorthand. I'm uninterested in the images that fill in all the gaps, whereas before, for example, when doing the Nicaragua book I was completely preoccupied with every detail.

These photographs of the Philippines aren't intended to be in a code, indecipherable and therefore insulting to an audience. The pictures are very static. They are of a time past that keeps moving way beyond where they are . . . They're kind of like stepping stones across a river between two worlds that are tremendously distant. I think that my pictures probably contain adequate information, but what's inadequate is their ability to help the viewer experience and care about what is going on there.

FR: You seem to be wanting to treat the reader as an intelligent human being whom you expect to know something about the Philippines, or as someone who can become knowledgeable, not as someone who's waiting to be entertained. You're taking the Philippines out of the arena of passive entertainment and putting it into the arena of actual real world change and political possibility. So I think that what you are talking about is fighting the media's tendency to deny the possibility of discussion with the reader.

To me, it is as if the publications want images for the reader's enjoyment in which people in some far away place are acting out a ritual that may well be simply a projection of our own problems here, our own preoccupations, but we see it acted out on another stage far away from us. It is diverting. In a Marxist sense it's kind of an opiate of the people, as religion was thought to be—mass media journalism where you manage to cathart your own conflicted feelings, your own anxieties, through conflicts that are reassuringly distant without having to confront your own problems.

You seem to be pulling back from conventional photojournalism and trying to start from a less overheated place. You are a witness, but not one who says this is what I saw, but one who says, this is what I thought I saw and we, the reader and me, really have to deal with it together and don't just treat me as an authority coming back from a journey regaling you with tales.

SM: I also think that the authority of the frame is very problematic because you work very hard to make a frame around something with any assurance. Then you come back understanding how limited it is, how that which is within the frame is inadequate. But you don't want to always have to tell the tale of everything that is outside of the frame—it's impossible. There's always that tension in still photography between what is inside and outside the frame.

FR: It seems to me that by framing your images problematically, by giving up the role of authority, you become kind of Socratic, questioning the nature of things rather than adopting the pretense of the television anchorperson. So what you're doing by not stating explicitly, conclusively, this is what's happening, you're opening a door slightly, saying here's a room full of questions about a country full of people, come and join me—a kind of "insufficient" photojournalism. I think that this stance enfranchises the reader in the journalistic process, the way that we theoretically at least expect people to be enfranchised into the political process.

SM: Yes. But on the other hand, the question in my mind remains, does the reader want that responsibility? And I find often they want us to know, they want us to impose authority for their own needs, and deny us the doubt. We are the professionals. It's kind of like going to the doctor. You don't want the doctor to suppose; you want him or her to be sure.

So the problem for the photographer remains: how to create images and a sequence that's sustaining and engaging, but asks people to wait, to not think they know, but to be suspended and uncertain along with those pictured whose lives are unpredictable and unraveling. It's as if the reader should not only witness but be implicated by the reality of change, not only the idea of it. As a photographer, you make a sketch, not a detailed drawing.

FR: Is that drawing ever finished?

SM: I'm not sure that finished is the right word but you get to a place where you let go, and a place or person or something you've thought about for a long time no longer lives within you. Finishing isn't forgetting; something is left to rest as if it's as much as one can understand, articulate, or feel at the time. I'm not sure one ever knows when anything will be finished. In that sense the images of the Philippines are a beginning, a work in progress. . . .

David Goldblatt: Home Land

Texts by David Goldblatt and Nadine Gordimer.

Embedded in the bricks, mud, stone, steel, and concrete of all the structures in South Africa are choices we and our forebears have taken. No building, road, monument, township, resettlement camp, dorp, or city can be, but for the choices that gave it rise and others that are a condition of its continued existence.

For as long as a building or structure is, it may "tell" something of the needs, imperatives, and values of those who put it there and of those who used it and of the ideologies upon which their beliefs and lives may have been contingent. The choices made, the decisions taken and sometimes enforced, the beliefs which gave them rise, all of these enter the very grit of the structures and are often deducible from it.

When buildings cease to exist as coherent structures, their remains or footprints may yet be eloquent not only of what ruined them but of what may follow.

There is evidence of structures erected by South Africans of the Late Stone Age which are perhaps as old as the tenth century B.C.

European settlement began at the Cape in 1652. The oldest modern structure still in existence is, appropriately, the Castle in Cape Town erected between 1665 and 1679 as a fortress to consolidate that settlement against growing opposition by indigenous people. The core of the history of this land in the 335 years since 1652 is its domination by white people, the subjection to them by force and institutionalized economic dependence of black people, and of sporadic and latterly of massively growing opposition by blacks and disaffected whites to the system of domination.

White hegemony approached its ultimate expression in the past thirty-nine years with the emergence of Afrikaner nationalism as the overwhelmingly ascendant social force in this society. The apotheosis of that force is the ideology of Apartheid. There is hardly any part of life in this country that has not been profoundly affected by the quest for power, the determination to hold onto it, and the expression of that power through Apartheid of the Afrikaner Nationalists and of their supporters and fellow travelers of other origins.

Innumerable structures of every imaginable kind and not a few ruins bear witness to the huge thrust of these movements across our land.

Now, Afrikaner nationalism, though by no means spent, is in decline. Change, probably convulsive, to something as yet unclear has begun. The first structures based in countervailing forces and ideology have made their tentative appearance.

These photographs attempt to probe and record a few of these concerns. In the geology of South Africa's structures, its choices, and the accretions of its history are to be read.

DAVID GOLDBLATT
from "Structures," 1987

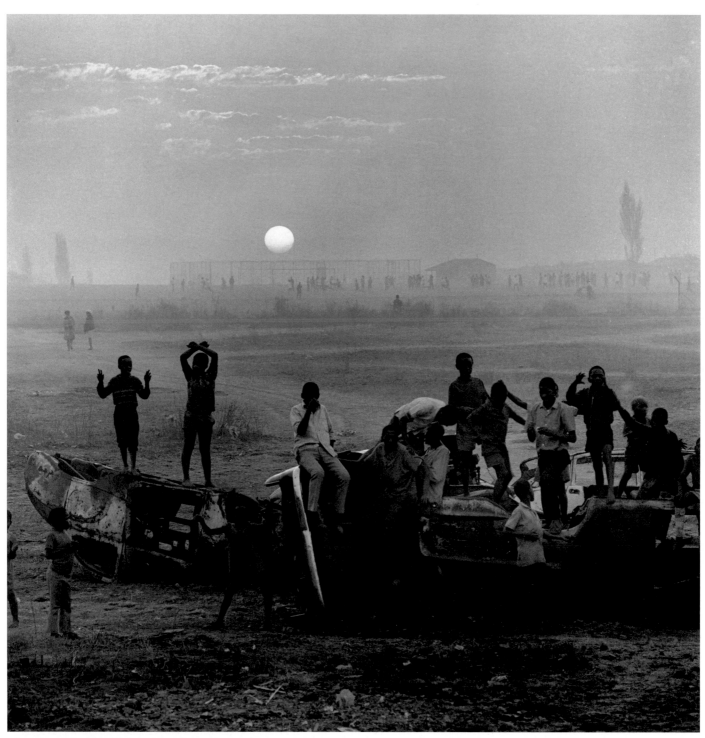

The Playing Fields of Tladi, Soweto, August 1972

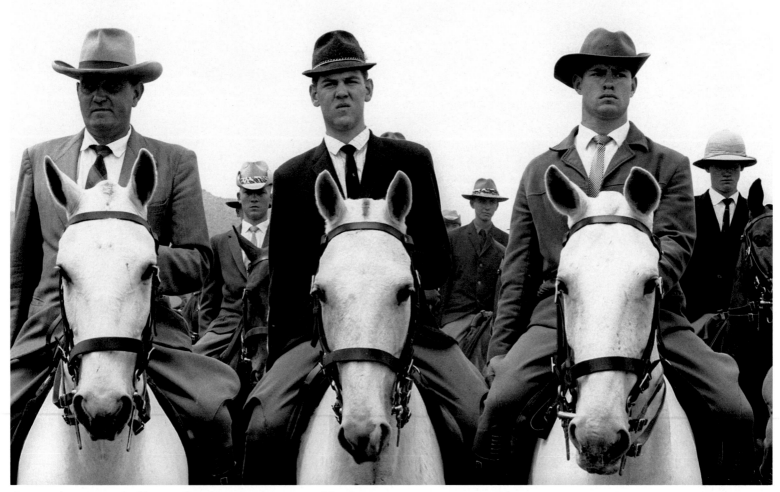

*Commando escorting Dr Verwoerd to the 50th-anniversary celebrations
of the National Party, de Wildt, Transvaal, October 1964*

 *I was brought up in Randfontein, and in the years of childhood before and during
the Second World War, I recollect that there was tension between the people in this
small town—for instance, I clearly remember incidents of anti-Semitism. They were
also the years of the Ossewa Brandwag. Although I was a child, these things made an
impression on me, so my early memories of Afrikaners were not entirely pleasant.
Also, because we tend to fence ourselves off from one another, I had little opportunity
of getting to know Afrikaner children.*

 *After the war there was a feeling of liberalization here. Then came 1948, and it was
something of a shock to realize that there was this very considerable force, this whole
structure of ideas and people that for me was something almost entirely unknown at
the time. One knew about the Nationalists, of course, but hadn't dreamed of the
extent and power of their ideological movement. This was something one had to
absorb into one's life.*

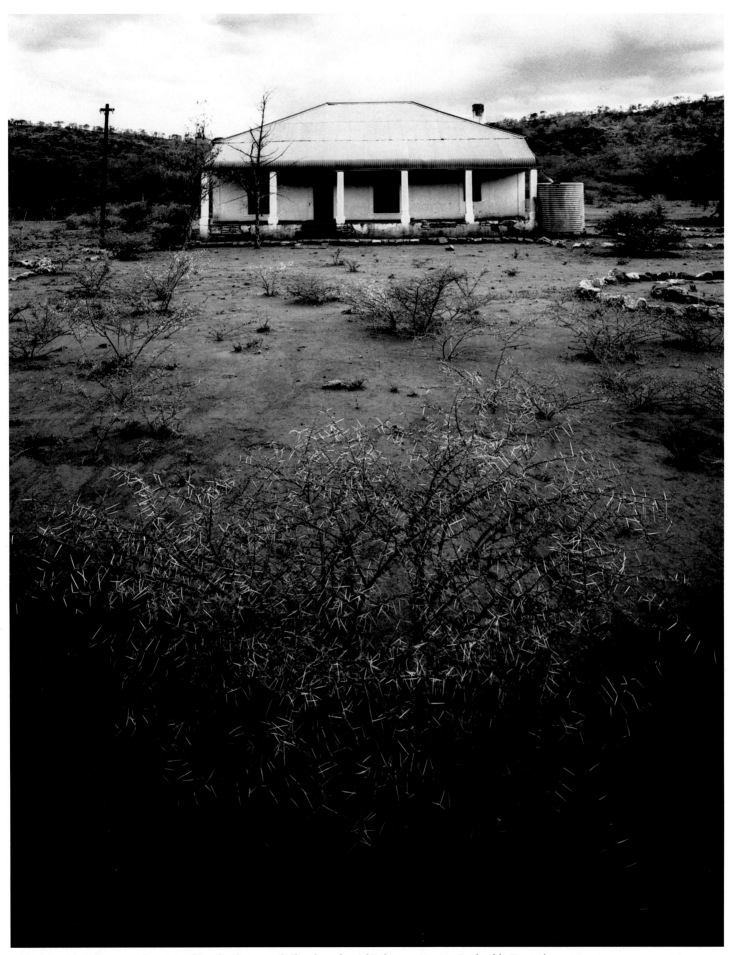

Abandoned farmhouse with encroaching haak-en-steek (hook-and-prick) thorns, Marico Bushveld, December 1964

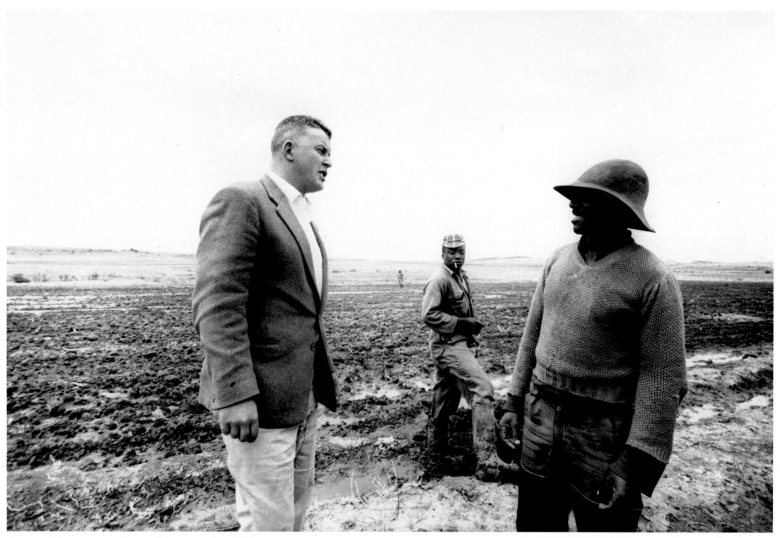

Farmer Johannes van der Linde with his head laborer, Ou Sam

 In common with many others of my generation, my constant thought for some years was to get out of South Africa. It seemed to me impossible to make my life here. But then, while working in my father's business, for the first time I really met Afrikaners, and I had to come to terms with what was for me a new understanding—that is, the rather stereotyped ideas I'd had didn't fit with the Afrikaner people I had to deal with. I began to know a little more of the language, and I began to enjoy it. I also became aware of the paradoxical way in which they represented much of what seemed quintessential in the South African situation. And so there grew up a much more complex view of the Afrikaner, and I began to feel the need to define this view, and to understand my own relationship with these people. In order to explore these things I began to take photographs of them. In doing this, I came gradually to know something else—that I no longer wanted to leave South Africa as quickly as I could, and that in fact I wanted to stay here, because however guilt ridden I might be, this was where I belonged. I was involved.

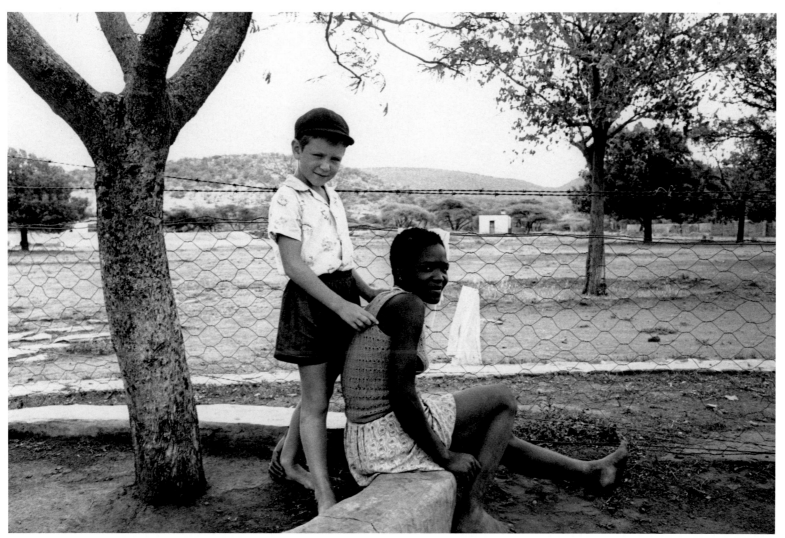

A farmer's son with his nursemaid, Marico Bushveld, 1964

I did a photograph in the Marico Bushveld of a young black girl who was the nursemaid of a farmer's son. It shows the two of them together in the yard of the farm. It was a picture of great love and intimacy. For me it encapsulates a great deal about this country, about the relationships of Afrikaner people, and more particularly about the relationships of Afrikaner men and black women. That young boy, at that time, had a close physical relationship with that girl, but there was no question that when he reached puberty the relationship would have to stop. He would have to readjust his whole thinking about his relationship to the black girl and to black people in general. This situation to me was pregnant with a great deal about this country.

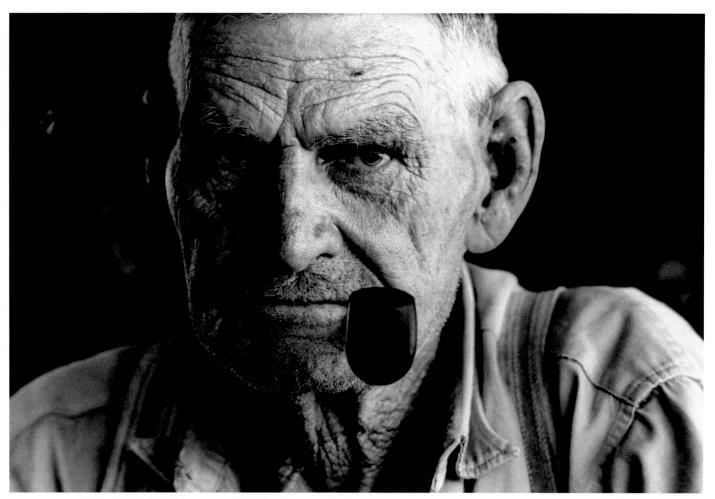

Oom At Geel, farmer, Marico Bushveld, December 1964

Oom At Geel and his father Oom Krisjan Geel were captured by the British during the Boer War. At was then fifteen and a half years old. "But I was no child. I knew how to ride and fight and shoot." Being Cape citizens and therefore rebels, At was imprisoned and his father sentenced to death. Later both were released. He thought that the British had been quite correct in their treatment of his father and himself, and he has taught his children that whatever the government, their duty is to stand by it. Much as he disliked the Verwoerd regime, he said that he would fight for it in war. He fought against the Germans in South-West Africa; the rebels in 1916; the strikers in Johannesburg in 1922; and, as a major, against the Italians and the Germans in the Second World War.

"Then I was a man," he said. "Now I am nothing."

At 79 he was farming near Nietverdiend in the Marico Bushveld, together with a new wife—his second. The names of several of the Geel family are to be found in Herman Charles Bosman's stories. Bosman seems to have embroidered freely on the lives of those he met and heard tell of when he taught at the Heimweeberg school in the district in 1925. And the few of those still to be found in the Marico in 1965 thought it neither strange nor offensive that he should have made free of their life stories and names. "Ja, dit was ons," they invariably said of Bosman's Marico tales. But except for At Geel's daughter, Mrs. van Staden, who was taught by Bosman and who fondly remembers how he gave haircuts to the girls, none remembered him with great affection. "Rough" and "wild" they called him. At Geel, who was chairman of the school committee when Bosman taught in the Marico, said that he gave them a lot of trouble. Then Oom At tells how, one day when he was at the shooting range, he held up an old rifle and called: "Who'll give me three pounds for this?" "I will," cried Bosman. When Oom At asked Bosman what he would do with the weapon, he replied: "Ed wil daarmee in Johannesburg gaan pronk."

A few weeks later Bosman shot and killed his stepbrother, probably with this rifle.

1965

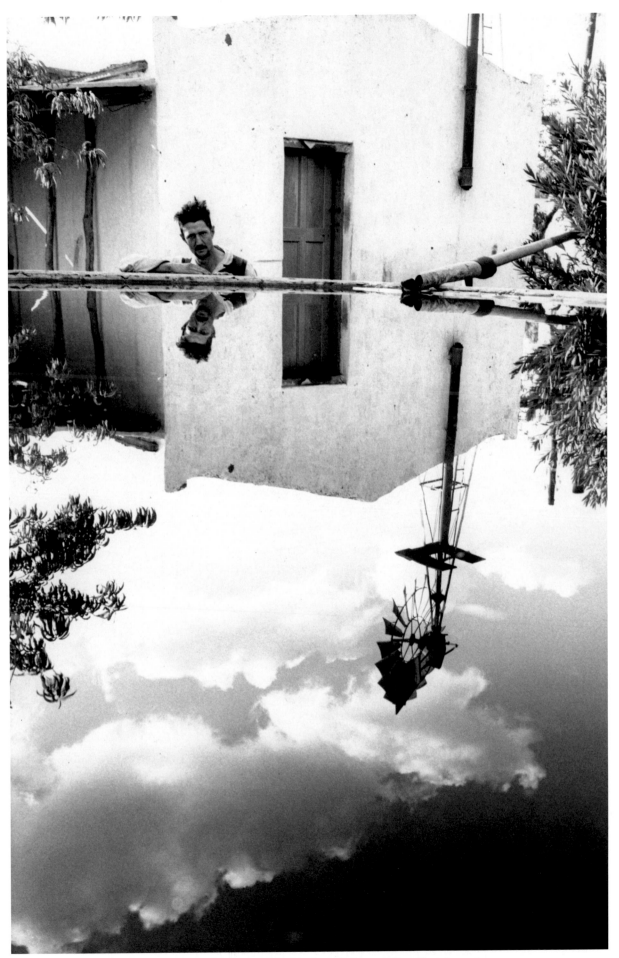

Railway shunter who dreamed of a garden watered by his dam, Koksoord, Randfontein, 1962

49

Out of the language of photography in South Africa can be made, to be local and particular, dompas photographs, beauty-spot photographs for Flying Springbok, *the South African Airways magazine, a smuggled photograph of the body of Steve Biko after he had died in detention, happy polaroids of crowds at Sun City, and news photographs of families being evicted from their homes. Because of this drama of environmental association, photography has become the most emotive language of the several dozen spoken to us South Africans. It has at the same time tended to make enormities and beauties equally commonplace.*

I think I could with exaggeration speak of Goldblatt's South Africa, but I know he would repudiate such an appropriation. It would go against the grain. A photograph can fix a moment of someone's life like a butterfly pierced by a pin. The subject becomes a species, an exhibition a taxonomy. If you look at these photographs, you will not find any such. Goldblatt does not sum up and take possession of South Africa here; he leads us into it. His photographs are a beginning, not a fixed moment. The more you look at them, the more you follow them into yourself, supply the holographic dimension they imply.

Very often the force of the image comes from the relation of the human to something he himself has made, works or lives with. Goldblatt sees "background" as integrally part of the subject, whether this is in the form of a room full of that person's possessions, or his place of work and the tools and the machinery that are just as intimately connected with his body and limbs. A splendid example of this symbiotic image is, for me, the photograph of the young man before the giant winder. The inevitability of the composition—the young man enthroned and entrapped plumb center before a great machine—the subtly contrasting surfaces bearing the same patina, one of human skin, the other of oiled metal, of face and machine: from all this the hard-won equilibrium in the face of industrialized man emerges.

Goldblatt's photographs taken in the mines seem to me to be the best photographs of men at work ever taken anywhere. The mystery—blessing and tyranny—of work, which should grant the dignity of labor but is more often the greatest agent of man's exploitation of man, is awesomely acknowledged. Lashing the kibble at President Steyn Mine is a vision of hellish beauty from a level of the underworld Dante's imagination never reached. But those shrouded figures, buried, moving through mists of dust and water, are not Shades; they are real men. Goldblatt doesn't let us forget the amaPondon and baSutho who walk above ground and are recruited as migratory laborers in places like the Transkei, from which, in turn, he brings us images of people living so close to material nothing that the connection made in our minds between the migratory laborer underground, the poverty that forces him to take wing in a WENELA bus, and the great wealth of the gold-mining industry is more stunning than any didactic photographer could make it.

In praising works of art in South Africa, it is usual to pay lip service if not obeisance to the moral role of the maker in creating "understanding" of our society.

Goldblatt's photographs, in their beauty and honesty, offer the very reverse of the easy panacea of "understanding." They cause us to face the ultimate implications of what we understand very well.

NADINE GORDIMER

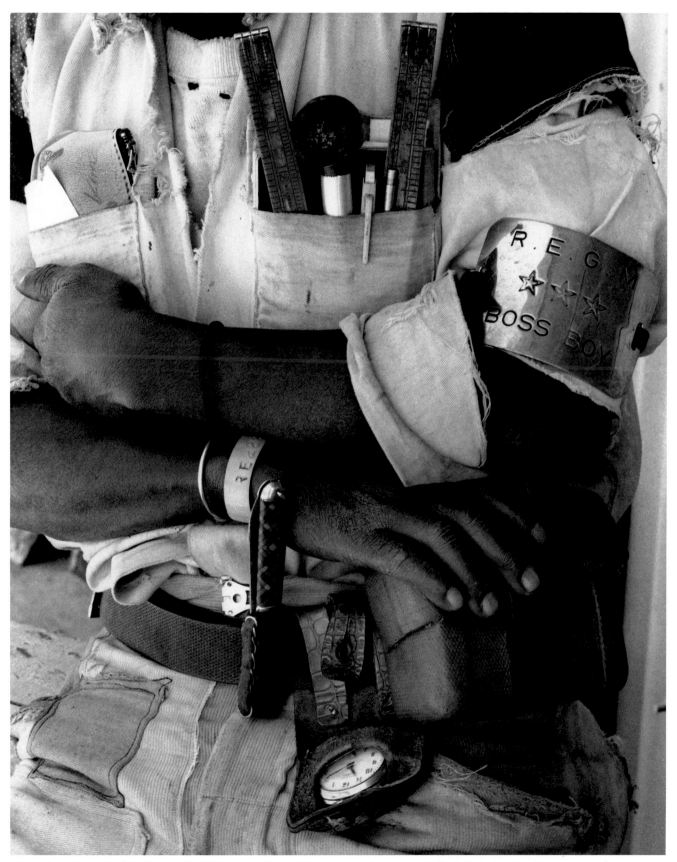

"Boss Boy," Randfontein Estates Gold Mine, 1966. In right pocket: tobacco pouch. In left pocket: clinometer for underground measurements and notebook for recording them. On left arm: company rank badge with three stars to indicate Mine Overseer's Boss Boy. On right wrist: company identity band. On belt: pocketknife, Zobo watch presented by company in recognition of accident-free work, and first-aid kit

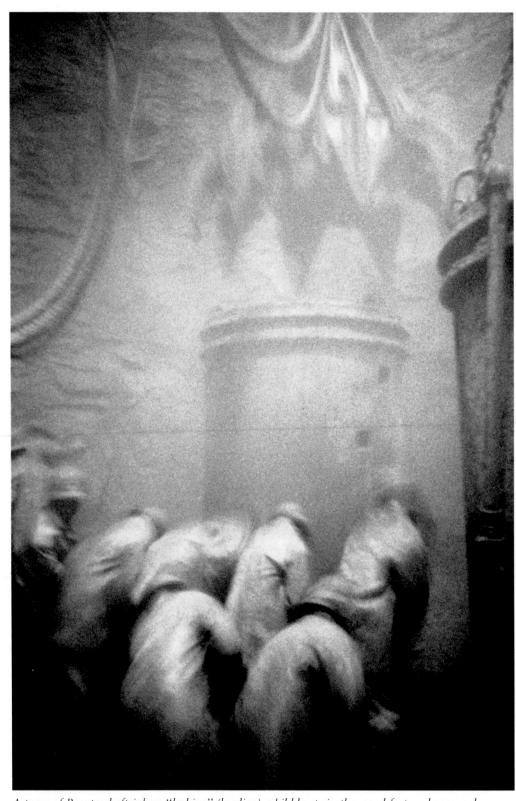

A team of Basuto shaftsinkers "lashing" (loading) a kibble at six thousand feet underground, No. 4 Shaft, President Steyn Gold Mine, Welkom, 1969

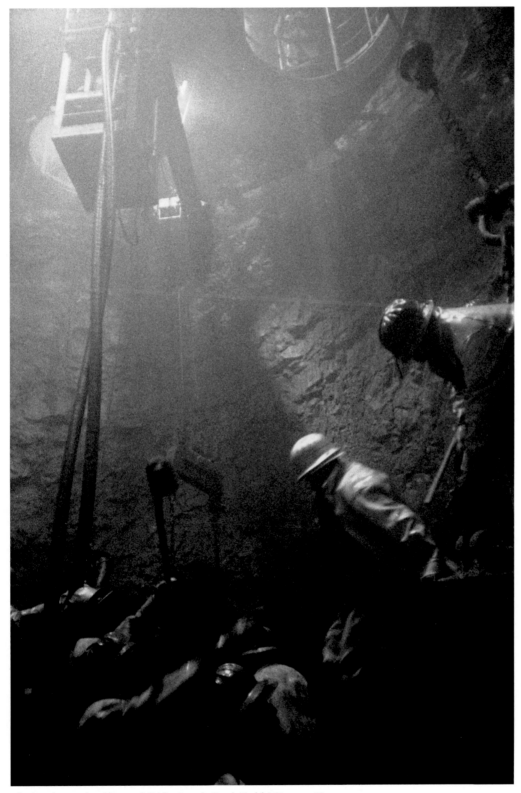

Shaftsinking: shackling a kibble, South Vaal Gold Mine, 1968

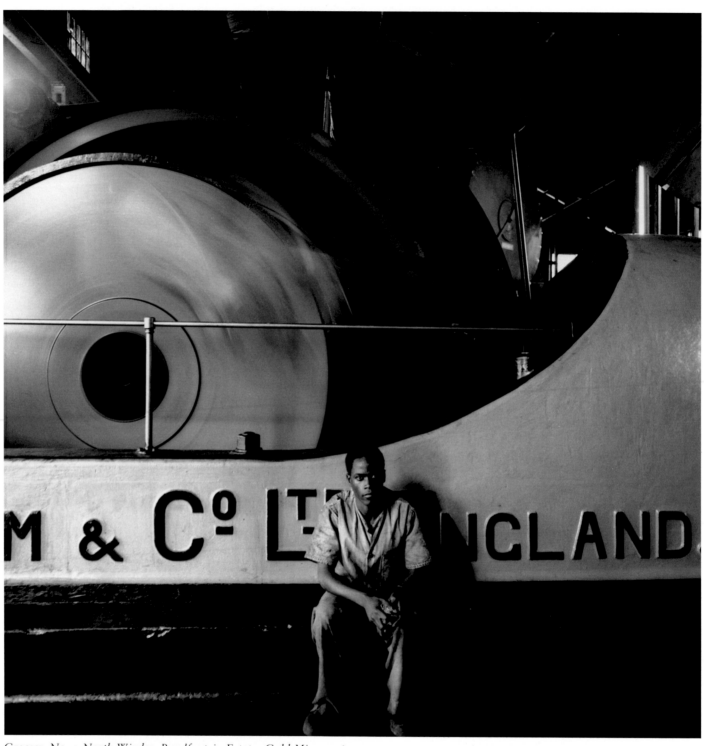

Greaser, No. 2 North Winder, Randfontein Estates Gold Mine, 1965

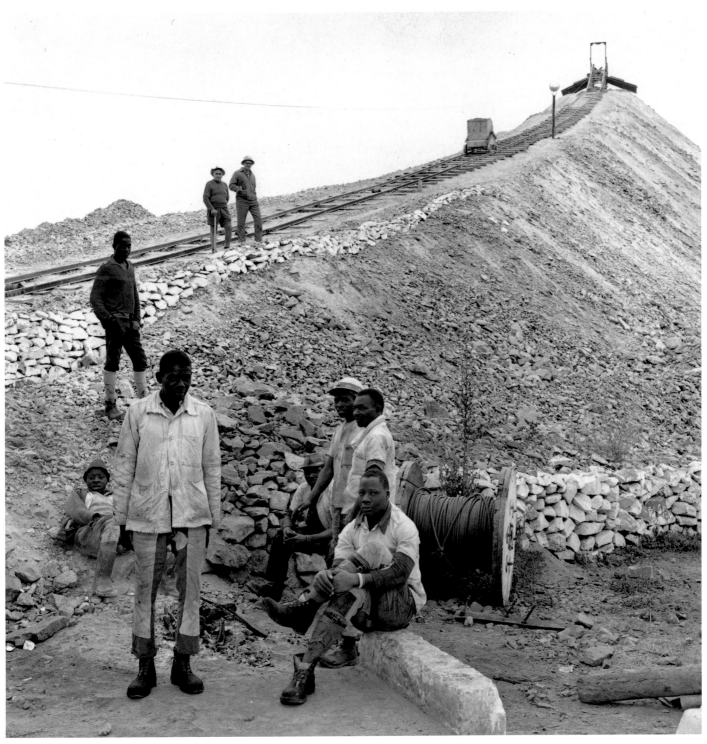

Gang on surface work, Rustenburg Platinum Mine, 1971

I don't think the camera, in my hands, is a gun. I don't see myself as being politically effective. Nor do I see myself using the camera to make statements that would be politically effective in the sense that they would lead people to do what they might not do otherwise. Having said all that, I have got to proceed on the assumption that the photographs do make a difference. The photographs are political and have significance in the sense that it is important for me as a person here to raise my voice.

In many cases I have been concerned with the preconditions of strife. When I photographed Soweto in 1972, it was clear to me that this place had to explode. It had to erupt. It was at a time when Verwoerdian apartheid was at its height and Soweto was a terrible place to live. It still is, but then it was worse. Photographing there, I was aware of a conundrum. Here are people living in the most appalling circumstances, living under constant threat of official action for one reason or another, yet there was a sense of people going about their daily business, going to work every morning, paying the rent, buying furniture on the HP, paying the HP installments. All the small things of daily life were going on normally, and people's aspirations existed in all this. Even within that system, people aspired to do the things people do everywhere. I was confronted with the strange puzzle of the choices people make. It seemed that people chose not to revolt. It was a conscious choice, otherwise they would have been up in arms and we would have had an armed struggle then. I think it might be said that now people are making other choices.

I took a photograph in Soweto in 1972 of an incident in a coal yard. Horses are used for hauling the coal carts in Soweto. A health inspector had condemned one of the coal merchant's horses whose mouth had been damaged by the bit. It was shot on the spot. When I arrived at the coal yard the horse was in the process of being dismembered on the veld. That in itself was a very raw experience; there is something raw about a big body being dismembered. But it was being dismembered in sight of the houses and the people. Furthermore, the parts of the horse were being arranged as if in some exploded view. While I was taking the photograph, there was a queue of women behind me with buckets and basins, waiting to buy up pieces of meat.

I realized that there were facets of Soweto that I wanted to pin down in quintessential images. One of the facets was the ubiquity of the motor car—not the motor car as we know it, but the hulks of motor cars. These were all over the place, every playground was littered with them. I was always on the lookout for situations involving these hulks that would enable me to put into these photographs something of the quality of life that goes on around these places. The children inhabited them like rabbits in a warren, and they gave the landscape a bizarre, almost a hellish, quality.

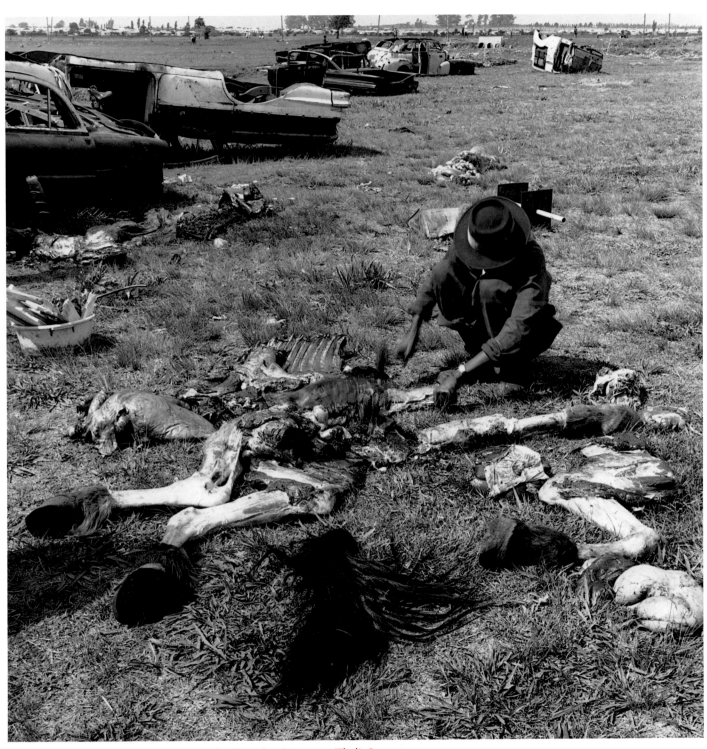

Butchering the horse of a coal merchant for the sale of its meat, Tladi, Soweto, 1972

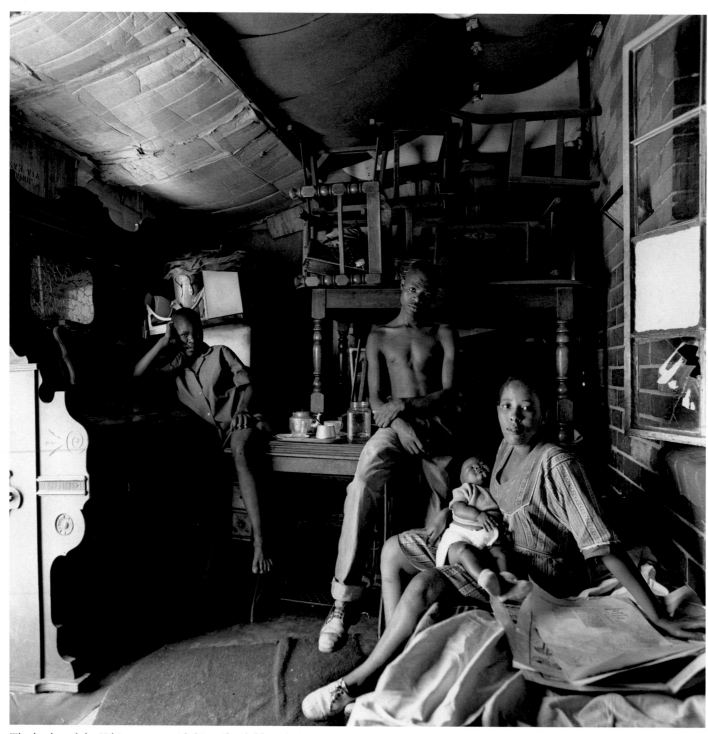

*The leader of the Vikings gang with his wife, child, and sister
at home, Orlando East, Soweto, October 1972*

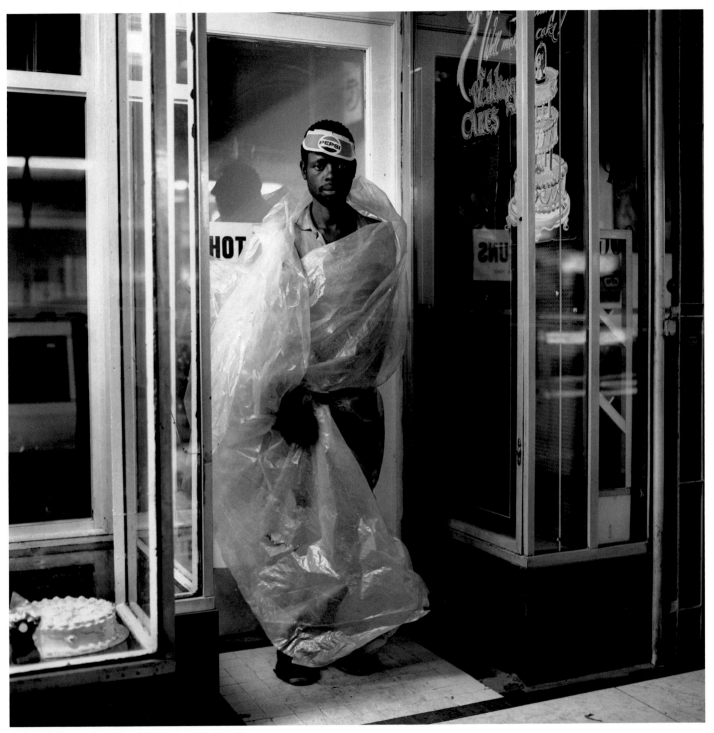

Man in plastic, King George Street, Johannesburg, 1973

 People have the right to privacy. I try not to infringe on their privacy. In other words, I ask permission to photograph people, and if they don't want to be photographed I never attempt to persuade them. I wouldn't pretend it is a natural process. It is not. I think that when one is being photographed, one becomes aware of a certain sense of occasion, and so with many people there is a kind of self-awareness that suddenly comes into play. I suppose I try to tune into that. I start from the premise of acknowledging my presence and the presence of the camera. We are disturbances. We are a strange event in the ongoing process of everyday life.

Detective at Highpoint, Hillbrow, Johannesburg, January 1973

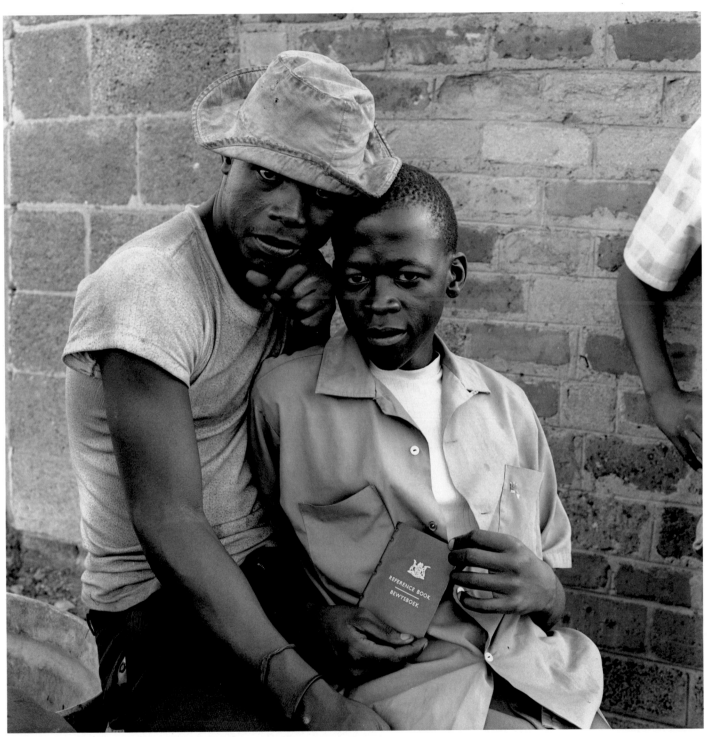

Young men with "pass" book. Any black person without a valid pass in his possession was liable to summary arrest. White City, Jabavu, Soweto, 1972

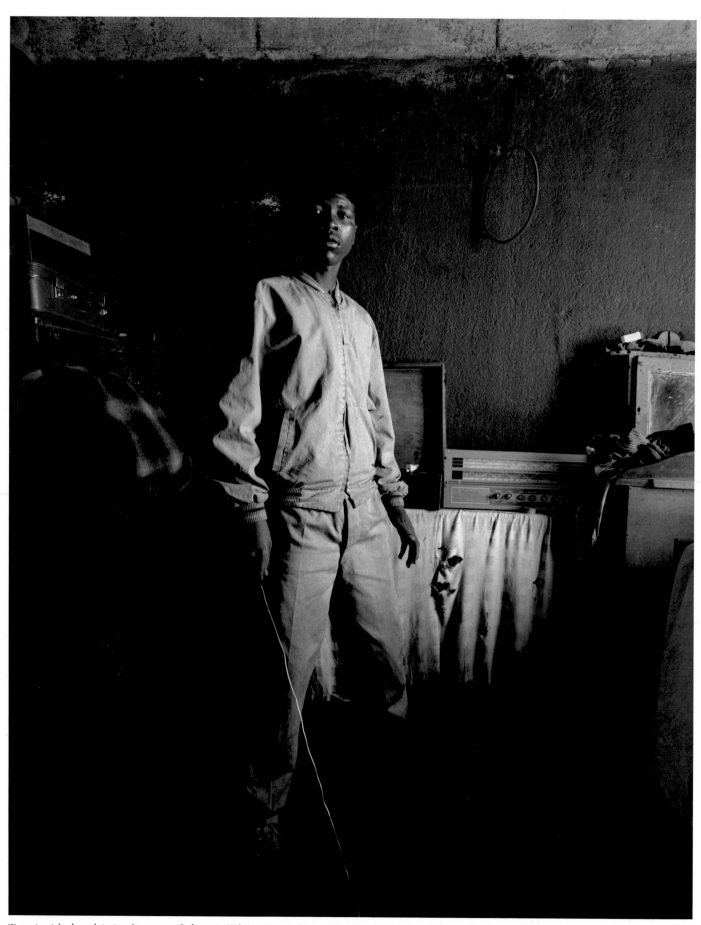

Tsotsi with draad (wire for street fighting), White City, Jabavu, Soweto, September 1972

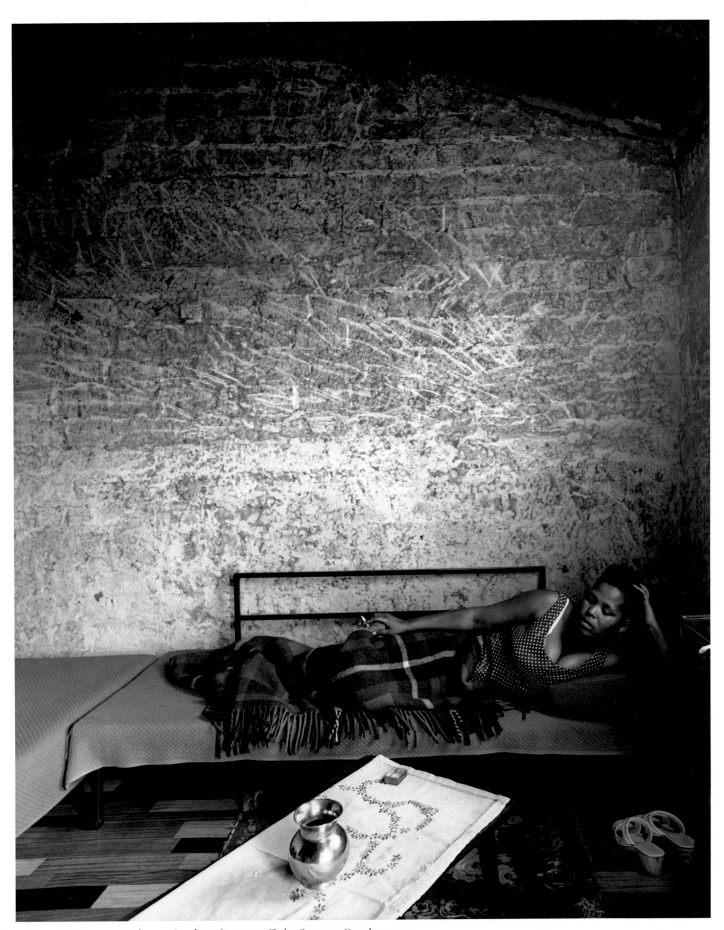

Margaret Mcinganga at home, Sunday afternoon, Zola, Soweto, October 1970

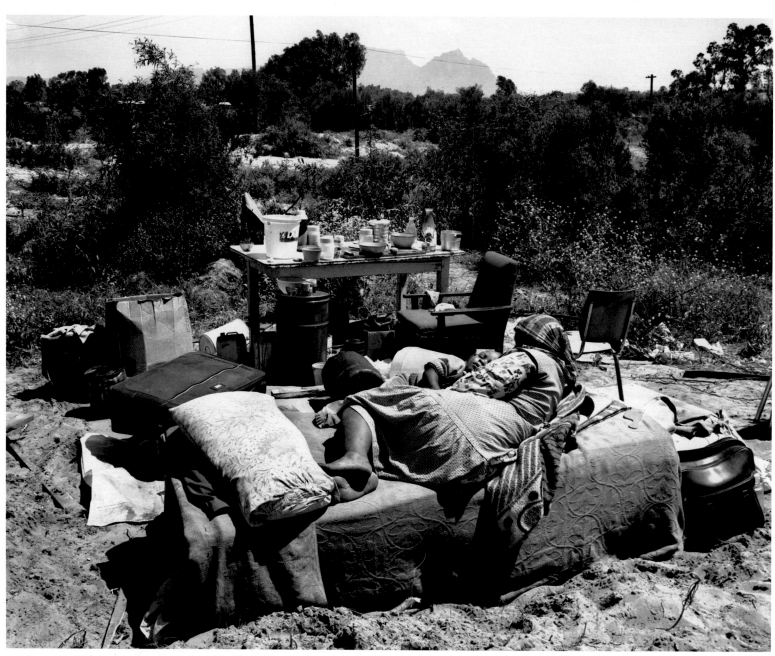

Mother and child in their home after its demolition by officials of the
Western Cape Development Board, Crossroads, Cape Town, 1984

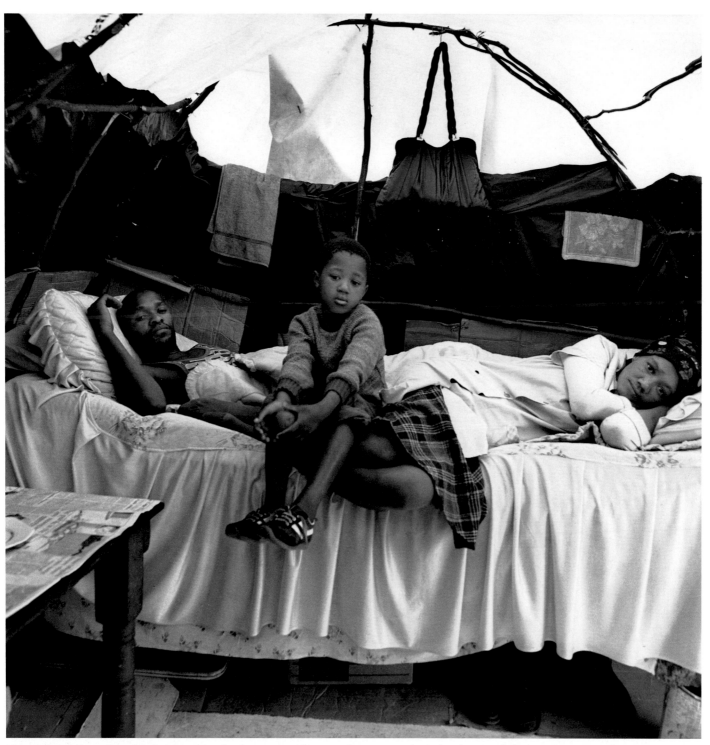

No work, no "pass," no legal right to employment or residence in the area in which they have settled:
a family in their shelter at KTC Camp, Cape Town. Their shelter had been demolished by officials of the Western Cape
Development Board more times than they could remember—perhaps thirty or forty times, they thought

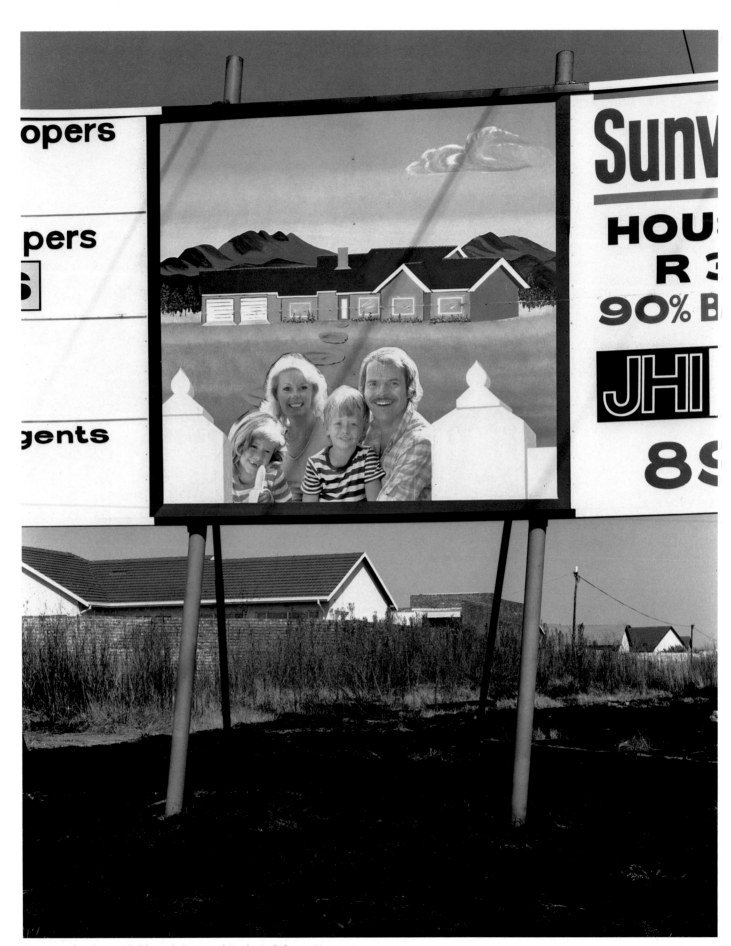

Property developers' billboard, Sunward Park, Boksburg, May 1980

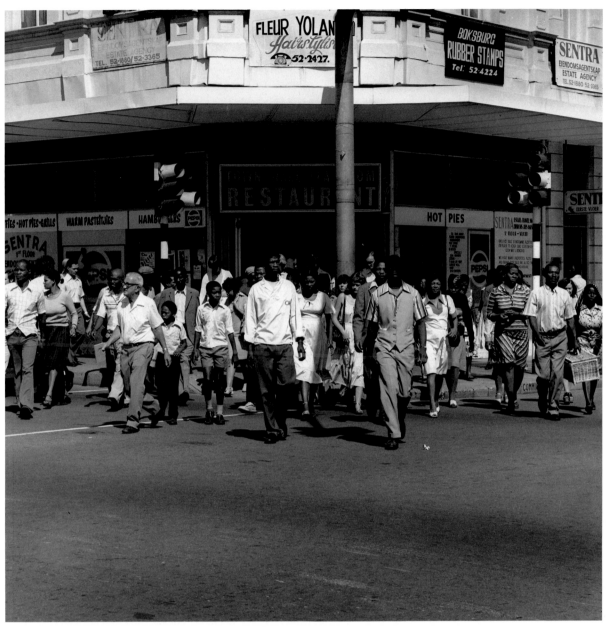

Saturday morning at the corner of Trichardt and Commissioner streets, Boksburg, 1979

In Boksburg I saw Randfontein, the community in which I grew up. So I was going back to look at something quite close to me, indeed quite painful. I chose Boksburg rather than Randfontein precisely because Boksburg was just a little bit further away from me than Randfontein and I could be a little more dispassionate about it. What I wanted to explore there was my sense of what it is to be white in South Africa. I am of Boksburg. It is my community in the sense that it is very much the kind of milieu in which I grew up and, it must be said, of which I am still a part. Even though I live in Johannesburg, we're not very far from Boksburg. Outside, beyond the place that I live in there is this madness, this bizarre society in which the most awful things happen with an appearance of normality that surpasses anything that you care to imagine. Within the community, again there is the sense of everydayness, of people doing the things that people do all over the world in middle-class communities. I was looking to explore the sense of white every dayness, of how it is possible to be normal, decent, in a situation that is in every sense mad and even evil.

Boksburg had qualities that were concentrated: the topography of this part of the world, the veld, the cutting light. The streets are marked out in a grid with lines painted on them that in a sense demarcated lives. I have discovered in South Africa, and in particular in our little town here, that we're very line conscious.

The fabric of this society permeates everything I do. I don't know if this is the case with other photographers. I would dearly love to be a lyrical photographer. Every so often I try to branch out and rid myself of these concerns, but it rarely happens. You take your first breath of fresh air and you have compromised.

Recently I became very aware of the people thrown into detention. There is the elementary fact that is lost sight of in this country, that they are put into detention without trial, without recourse to the courts. It has become necessary here to remind ourselves of this fact. I have catalogued the faces of some of the people who have been in detention with something of their life and what happened to them in detention. I have also met with some who have been abused in detention. The photographs might in some small way, through their publication, act as a deterrent to further abuse or even to detention without trial itself. As the struggle for the survival of the apartheid system becomes more acute, so the system becomes more restrictive, especially with regard to the flow of information. We are going into a period of long darkness when the restrictions will become more severe. I am aware of photographing things that are disappearing and need to be documented, but in another sense I have a private mission to document what is happening in this country to form a record. There are many other photographers engaged in this. I regard this aspect of our work as very important, so that in the future, when the time comes, people will know what happened here, what transpired.

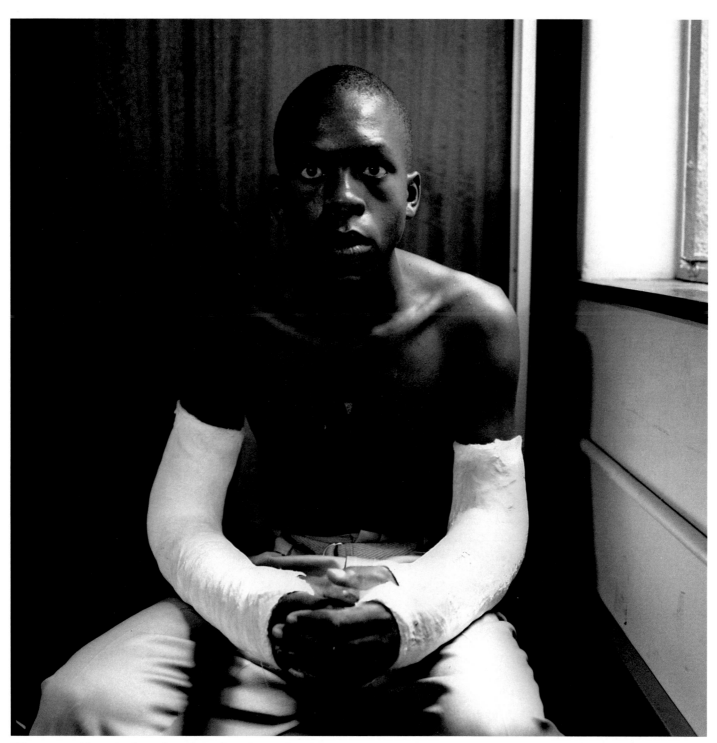

Fifteen-year-old youth after release from detention, 1985

People and Ideas

ISSYK-KUL: A CONVERSATION WITH GORBACHEV
by Arthur Miller

Few international meetings on Soviet territory can have been so informally prepared, but something new had happened some eleven months before in a meeting of American and Soviet writers in Vilnius, Lithuania, that made this inevitable. Chingiz Aitmatov, a Soviet novelist and playwright of great renown and political standing, had broken ranks and agreed with the complaint of a foreigner—me—that, as I had rashly put it, "There is no use our trying to keep bridges open between us if there is not to be candor between us. The truth as many of us see it is that it is hard for us to tell you people apart because you all give more or less the same answers to every question we ask you about your society and your lives." It had not of course occurred to me then that all this would lead to a two-and-a-half-hour conversation with Soviet leader Mikhail Gorbachev ten months later.

The Soviets had been outraged then, and I had felt close to despair about creating any real connections between Soviet and American cultural people that were more than diplomatic and routine. The problem, it had seemed to me then, was that any meeting with Soviets had to be supervised, in effect, by the Writers Union in the case of writers, or by some other Party-dominated disciplinary organization where scientists or others were concerned. In short, it was all but impossible to approach them person to person and without some prearranged agenda and official supervision.

Almost a year passed when my phone rang with the voice of Aitmatov, incredibly, shouting into it all the way from his home in Khirgizia, a republic on the border of China and Afghanistan, two hours by air from New Delhi. I had already had a letter from him outlining a plan to gather writers, scientists, directors, and musicians from Great Britain, France, Italy, Spain, Cuba, Turkey, India, and Ethiopia, and to sit us all down to speculate about how we were to get the world safely into the Third Millennium, as he put it. There would be some ten people, including Federico Fellini and Friedrich Durrenmatt, both of whom promised to come. (Both sent cables saying they could not come but wished to attend future meetings.) It seemed harebrained and interesting primarily because there was to be no supervising organization and no agenda beyond the general idea of a discussion of the future. "It is my personal invitation," Aitmatov repeated, "and we will all be speaking for ourselves alone."

I had a certain amount of faith in him because he had shown courage in pressing the limits of Soviet discussion in his novel *A Day Lasts Longer than a Century*, in which a small people, not unlike Aitmatov's own Khirghiz nationality, is seen as being all but crushed by the steamroller of a larger culture, which eviscerates even the memory of the victims who manage to survive. In his play *The Ascent of Mount Fuji*, a group of intellectuals has to confront its own betrayal of friends who resisted Stalinism.

At the same time I knew that Aitmatov was an elected member of the Congress of Soviets, and had in fact left our meeting in Lithuania to speak just before Gorbachev's address, a most prestigious spot on the program.

Thus his invitation, sincere as it might be, was also coming from high in the government. With sixteen others I spent three days in the comfortable health resort on the banks of one of the largest inland seas on earth, Lake Issyk-kul, where we spun out our ideas on the time to come. Alvin Toffler; his wife, Heidi; James Baldwin; his brother David; my wife, Inge Morath; and I were the Americans. Alexander King, head of the Club of Rome; Dr. Augusto Forti, an Italian physicist; Claude Simon, the Nobel Prizewinning French novelist; Afewerk Tekle, an Ethiopian painter; Peter Ustinov, the British actor; the novelist Lisandro Otero from Cuba; Frederico Mayor, biochemist of Madrid; Yasar Kemal, the Turkish novelist; Omer Zulfu Livanelli, the Turkish composer; Narayana Menon, head of the Academy of Dance and Music of India; and Aitmatov were the participants.

After three days of discussion, when we were preparing to leave for the four-hour flight back to Moscow it was announced that we were to be met by Chairman Gorbachev on the day after our arrival. I assumed it would be a brief diplomatic hello lasting a few minutes. As it turned out our conversation—which is what it became after a few short introductory remarks from each of us—took two hours and thirty-five minutes.

We met in the newish office building facing Red Square that houses the headquarters of the Communist Party of the Soviet Union, the very heart of darkness or light, depending on how you look at it. The finish of the building is remarkable among Soviet buildings for its tasteful simplicity and a certain deep hush in its surrounding acoustics. A hatless soldier without gunbelt or decoration shepherded us into the elevators, and when we emerged on an upper floor another led us into an outer chamber where we waited for a couple of minutes until a door opened and Gorbachev appeared with three interpreters and shook hands.

He wore a brown suit, beige shirt, and striped tie, and unlike his predecessors in his job did not look bloated with drink but bright-eyed and ready for a spot of

Inge Morath, *Delegates to Forum for a Nuclear Free World greet Andrei Sakharov, a recently released dissident, Moscow*

Inge Morath, *Raisa Gorbachev receiving Forum guests, Kremlin, Moscow*

work. He had an eager grin, and there was a certain wit in his eyes. From my writer friends in Moscow I knew that he was in the habit of reading a lot. When we shook hands he said he had seen or read all of my plays and very much admired them. I was tempted to tell him that my plays have been blacklisted in Russia for the past sixteen years, since my and my wife's book *In Russia* appeared, but I thought it best to take one thing at a time since he would have no connection with my suppression in any case.

He had a look in his eye that I can only call contemporary. There was a certain haste in him that reminded me of John Kennedy, a desire to get to the point quickly. And Kennedy had also wanted writers to like him, as had another leader with a similar personality, Moshe Dayan.

Gorbachev now led the way into a conference room with a long table that might seat thirty. He had no advisers or assistants except for one man who sat apart at a table and appeared to await orders. Four interpreters sat along the walls with earphones that picked up our voices from speakers under grilles in the tabletop. I decided to take notes because it suddenly occurred to me—I was not quite sure why—that he wanted to say something that would reach beyond this room. There are two forces in this world that can make peace or war, and here was one of them, and I thought I ought to be sure of what he was saying.

He had no prepared notes, but jotted on a pad when others spoke. He began by greeting us all. My notes say that he soon began speaking of President Reagan, to whom he had complained, he said, that almost fifty percent of the movies shown in the U.S.S.R. were American but very few Soviet films were played in the United States. There was a noticeable satiric edge to his voice and a sharp grin when he spoke of this disparity. He would return to this subject later.

He said that he himself had never been to Issyk-kul, and laughed lightly at the idea that we had been where he had not.

Aitmatov led off and spoke for five minutes, outlining some of what we had tried to do in our three days of talk. What it had all come down to fundamentally was a shared belief that the existing ideologies and bureaucracies in the various countries were more willing to block new ideas about how the world should be run than to confront uncomfortable facts. He reported what I said in Issyk-kul, that the views of Adam Smith and Karl Marx were a hundred and fifty to two hundred years old while our technologies would have been unimaginable even fifty years ago, and that no orthodoxy ought to stand in the way of mankind in this dangerous time. The Tofflers had given us more detailed discussions of technology and its probable effects on the future, but Aitmatov tried to give Gorbachev the flavor, emphasizing the need for a free flow of information within and between nations.

We hoped, Aitmatov said, to meet again in other countries as time went by, to bring in more people who were inter-ested in thinking about the future, and that we had decided to have no budget and to use his house as a mail drop to which we should periodically send ideas and proposals. In one of our sessions somebody had cooked up the name The Issyk-kul Forum, and this was as close to an organization as we wished to come.

In fact, I had sensed during an early session that some of the participants were assuming that a new organization was being born here, and I had candidly announced that I wished to head this off. We could hope to wield influence not by numbers but by the usefulness of new ideas, and for this it was best to keep the ranks down to those who might have such ideas. I thought a few of them, mainly the Marxists, were surprised that we were not to enlist masses of people, but they soon saw the light and thought it a good approach.

Aitmatov seemed on familiar terms with Gorbachev, and I knew a few other writers who periodically talked with Gorbachev about the way Russia was moving. Gorbachev now spoke briefly about "the lack of new thinking in our civilization." I thought that this, spoken to foreigners, was in itself something new for a Soviet leader; and I realized once again how stupefyingly arid the past contacts have been with these people.

Señor Mayor spoke rather diplomatically, I thought, touching on the habits of science as a possible model for us now, specifically its openness to contradictions of given proofs.

Mrs. Toffler spoke for a few minutes.

Inge Morath, *Andrei Voznesensky, Russian writer, at the Peredelkino writer's colony.*

With her husband she espouses a philosophy they call Futurism. The Russians have shown great interest in this and in *Future Shock*, her husband's book, which I had not read but which apparently appeals to them as a promising opening for the technology in which they place much hope for the development of the country.

Alvin Toffler himself soon followed, telling Gorbachev that he and his wife had spent many years as workers in auto plants and had developed their ideas from practical experiences.

Gorbachev said that ideas and practice had to be one, and this was one of the few clichés he managed to commit, and did so emphatically at that.

Alexander King spoke. He is president of the Club of Rome, in effect a think tank trying to come up with new social concepts, some of which have in fact been adopted by governments of all sorts as well as by industry. Its members come out of big business, academia, and government. Gorbachev seemed to know about the club and its work and approved of its free approach to problems, he said.

To Alvin Toffler Gorbachev said that his main worry about technology as a solution to social problems was that it sometimes lost sight of the effects on hu-

man beings. "Lenin said that the weaker point was in the attempt to combine Socialism with interest," which I took to mean that Socialism could not be strong until it expressed the actual interests of the people and not merely their ideals or the ideals of activists foisted on them.

"In 1984," Gorbachev said, "I went to Britain and inspected an auto plant where they produced a new-model car after four years of work. I admired the technology, but I asked them what was to happen to over a thousand workers whose jobs had been eliminated." Toffler acknowledged that the biggest future problem was that of people being made redundant. Gorbachev repeated that this was the heart of the matter and that he did not yet see a solution. This I found surprising when Marxism was supposed to have a solution to everything, but apparently not anymore.

Menon of India said that of course peace was the number-one problem now but that the Third World was near starvation or already over the edge. He said that population control and the vestiges of colonialism were also vital to confront.

Ustinov thought it encouraging that we, who had no power or positions in government, should be received in this way, and I thought he might have in mind the unlikelihood of a Reagan or Thatcher ever doing the same with a similar group. Perhaps I was reading into him, but maybe not. He is a fabulous mimic, and I had a flash of him with Gorbachev and Reagan together, arguing in his mock-Turkish with the novelist Kemal as I had seen him do; it was easy to imagine both leaders laughing their heads off. Gorbachev, it seemed to me, shares a certain earthiness with Reagan, which helps account for their persuasiveness as politicians, for even in this system Gorbachev must have swayed a lot of powerful men to get to the top.

Kemal, a giant with one eye and a basso voice, author of novels that are bestsellers all over the world, bellowed condemnation of education that leads people to love war and violence. His fellow Turk Livanelli, a composer whose new record of songs had recently won an impressive international award and who, like Kemal, had been in and out of Turkish prisons for years now, thought that governments

had to reinstitute their links with intellectuals. I should have thought that given Turkish "links," which usually ended with the intellectuals' going to jail, might be better avoided, but this is a minority and particularly American view—as I would shortly be reminded.

Tekle, the tall and noble-looking Oxford-educated Ethiopian painter, said that this gathering had reinspired him to make his art reflect the aspirations of his people, with whom he had decided to join his fate instead of remaining abroad in an ivory tower. "An artist must be useful to his leaders," he said, while at the same time "Issyk-kul had given me a view beyond Ethiopia."

If this seemed to contradict the notion of freedom from orthodoxy that we had all been discussing, it may have been due to a genuine rush of enthusiasm brought on by Gorbachev's proximity to him, something that would doubtless count heavily in his favor at home with the military Marxist leaders of his country. At the same time he was undoubtedly speaking from the heart.

But Gorbachev said, "A writer should write about the destiny of peoples. Style and manner is up to you. This is my only request." But there would be more on this in a moment.

Inge Morath, *Arthur Miller and Peter Ustinov, the British actor, Lake Issyk-Kul*

Inge Morath, *Alexander King, president of the Club of Rome, at the Kirghiz Writers Union, Frunze*

Tekle described a stained-glass complex he was designing, and Gorbachev said, "I understood the beauty of stained glass only after I saw Notre Dame in Paris."

In my turn I said that the job of the artist was to speak truth to power; that I sometimes thought of my anthropology professor, who would give an exam to a new class on their first day. His question was, "What is the function of a hospital, a library, and an army?" He would let the students write for a few minutes and then announce that they had all failed.

"The function of a hospital is not to cure the sick but to continue being a hospital. The function of a library is not to give out books but to continue being a library. The function of an army is not to defend the country but to continue being an army." Gorbachev first looked surprised and then laughed, as much in surprise as in approval. I went on to say that an artist works alone and needs spiritual space in which to find his way, and that the orthodoxies everywhere were more likely to trip him up than help.

Gorbachev sat silent now, collecting his thoughts, jotting a few words on a sheet of paper. The smile had gone from his face. "Miller says he creates alone. But he creates alone for the people. I am on your side, whoever attempts that.

"You came here to think about avoiding war. I see a lesson in this kind of journey, this kind of attempt." Was he referring to Reagan's trip to Iceland? "I talked recently with a group of scientists from various places in the world and said that politics needed scientific argumentation," as opposed to assertions of ideological conviction, I presumed in this context.

"Politics," he continued, "needs to be nourished by the intellectual part of each country. The intellectual is more likely to keep the human being at the center of his examination. Any other concentration is immoral. If you look at recent history, human beings always have enough intellect to discover the causes of calamities, but sometimes only after trouble has come.

"In this spirit I welcome you, in the Issyk-kul spirit which is apparently an attempt to find a fresh understanding of the world today.

"I read and reread Lenin. In 1916 he wrote, 'There must be a priority given to the general interest of humanity, even above that of the proletariat.'" Gorbachev paused and grinned. "And I wish 'the other world' would also realize this," he said.

At this point there was a confusion in the translation, but through the tangle I believe I heard, ". . . whether President Reagan has truly renounced nuclear war." And then Gorbachev continued in the clear, "What if we cannot avoid nuclear war? There will be no chance to correct such a mistake."

He again referred to his suggestion to Reagan that if the Soviets were permitted to broadcast within the U.S., they would cease jamming the Voice of America. And again, "Fifty percent of films shown here are American. We could stop them, but except for pornography and violence we do not." He reported that Reagan had told him that the showing of Soviet films in America was a commercial question, but he seemed either not to understand this or did not really believe it a satisfactory answer.

"I told him, 'Mr. President, show more Soviet films and your commerce won't suffer, I assure you. And no one will be poisoned by more information,'" through these films, presumably.

"But our first responsibility is to prevent nuclear conflict."

I thought him a bit shy to be in front of what he called "men of culture." He said that Tolstoy had been worried on the eve of World War I by the approach of that conflict, but had said, "The warmakers have the money, but the writers have truth." Gorbachev then went on, "New thinking is emerging in the Soviet Union, in our political and cultural life. I went to Iceland with proposals that were absolutely unprecedented. But Reykjavík was barren of new thinking. We did not approach that meeting with ultimatums but with far-reaching proposals. . . ."

He broke off, his face deadly serious. "But we are not hopeless. It was not a failure. We did advance. Reykjavík showed certain possibilities and also clarified what steps were needed to come to an agreement. However, propaganda interfered greatly, propaganda by various interested cliques. But the reality remains and it is not hopeless."

Now he leaned back in his chair and appeared to relax his debater's tone into a more meditative mood. "We are in an

Inge Morath, *Claude Simon, French novelist, Bolshoi Theater, Moscow*

interesting stage of our development now. It isn't that we will give up our beliefs, but we must seek out their deformations and set them right. We are now in the process of restructuring Soviet society, emphasizing democracy and openness. And the support for this approach to reform is greater in the country than it has been in years." He continued on about *glasnost*, or openness, candor, a willingness to listen, as he had indeed been doing for most of our two and a half hours.

"Of course there are differences between and within countries," he said, "but they must not be allowed to stop us. In fact, we must use them to build new structures." This was a departure from the official Soviet stance, which insists that in principle most social problems are already solved and that the solutions only need time to become visible.

Aitmatov now picked this up and said that our forum was proof of what this new policy of allowing the expression of a variety of views could bring to the country. We had only begun to feel out the way to proceed, but this nonconformist approach had enormous promise, he thought.

Gorbachev agreed: "Some people are frightened by this kind of thinking. But we will press on. We are not afraid of ideas. In any case"—and here a sudden hardening of his grin and a sharpness in his tone were striking—"Russia always knocks out anyone who tries to interfere!" He laughed sophisticatedly but nonetheless with undiminished intensity as though a nerve had been touched. "Two hundred eighty million people are being told to ask questions. Our society is on the move."

And now came a curious reference, which seemed to fly out of the blue, quoting the poet Andrei Voznesensky, a good friend of my wife's and mine. I lost the quote, but I wondered if Gorbachev's mentioning Andrei, alone of all Soviet writers, was his way of showing support for the poet who had only the previous week published a new poem of outrage at his discovering a grave in the Ukraine of Jews from wartime whose gold fillings had recently been knocked out and their bones dumped back into a hole, never to be mentioned or memorialized by any Soviet agency or newspaper. Quite evidently, as I knew from other sources, the publishing of this poem was a challenge to the anti-Semites who were being faced down these days by the Chairman's new vision of Russia, and this abrupt mention of the poet was taken as another proof of which side he was on.

We shook hands again and left. Next day I would read of Gorbachev's being quoted as saying that "the Americans are terrified that we may become a democracy." There would also be a new report in the press that even now the full extent of the pollution caused by the Chernobyl explosion has not been revealed. Nor will Western reporters yet be allowed, as Soviets were allowed in the Three Mile Island disaster, to investigate this story, which, after all, continues to affect Europe and the world's food and water.

Coming directly from Khirgizia one has a sense of the immensity of this last of the empires, at whose apex Gorbachev sits. To move that continental mass into modernity is the work of a Hercules when one considers that so little of what Russia makes is yet salable on the world market; she is the only empire in modern history to import finished goods and export raw materials—her gas and oil, and, more important, so many of her geniuses who cannot function under the Byzantine controls of the Party. There seems no doubt of what this intelligent man wishes for his country. For now that seems to be all that can be said with any assurance.

MEN'S LIVES
A review by Nan Richardson

Men's Lives: The Surfmen and Baymen of the South Fork. Text by Peter Matthiessen, with historical and contemporary photographs. Published by Random House, New York, 1986 ($29.95). A two-volume deluxe edition was privately published by the Rock Foundation, 1986. ($200.00) Available through Aperture.

Men's Lives evokes an incontrovertible sense of place, of time long gone, hung on the dry bones of fact. An encounter with a culture being liquidated by pressures on both the land and the sea, it is a peculiarly full and rich book, filled with heroic portraits of the descendants of the original English and Dutch colonizers and whalers of old, who challenged the order of creation on the deep, as their descendants do now. With its vivid and exact language and relentless narrative and its potent photographic imagery, *Men's Lives* conveys a wide horizon, an enlarged imagination that grew from the intersection of five very distinct worlds.

The chief protagonist of the book is an almost anthropomorphic nineteenth-century nature, whose voice speaks in the cycles of waves and fog that engulf the world of the fishermen, a nature ruthless in what it offers or takes away. The images of abundance and force in the pictures illustrate that same restless magnitude, and the roll and sweep of the text conjures less an essay than an epic poem. It is a nature ambiguous in character: both the wild and treacherous sea of the cover photograph by Dan Budnik, where a dory veers against an immense dark wave, and the reflective serenity of Lynn Johnson's nesting swan are the stuff of myths, of a nature mediated and unraveled through intuition alone. Pictures like the facing images by Danny Lyon and Doug Kuntz, of fishermen staring at a rough sea, wondering at its terror, its fabulousness, are at once fatalistic and merciless and peculiarly personal. One journey onto the sea ends only to begin another—all different and all the same. In the minute descriptions of the craft— setting the net, tying on the bag, winching and scraping—the pain of the work and the stalking and hunt it represents are vivid. In the face of Stuart Vorpahl wrenching at the oars (photographed by Dan Budnik) the struggle is engraved. The notes of homelessness, exile, abandonment are all sounded. One can almost hear Melville's Ishmael calling out that all that man ever found when he searched the waters was a reflection of himself. That brooding interrogation of nature is the refrain of *Men's Lives*.

Against that backdrop, and in relation to it, the Bonackers (inhabitants of Acabonack Creek) of the South Fork of Long Island are introduced. There is a certain fatalism in their story, as though they, like the schools of fish that have mysteriously waxed and waned in the waters off Montauk Point, might follow in their wake. This tightly knit group of a few hundred families have intermarried and

adhered to a single way of life for over three hundred years. Their inbred speech reflects the accent of a long-forgotten native Dorset. A tribe of sorts, they find themselves now compressed between the refuse of the industrial age, its pollution of the rivers and the disastrous blow to spawning that engendered, and the laws produced by and for urban populations, which restricted the fishermen's livelihood and increased the difficulty of survival on the land as real estate chipped away acre after acre that once was theirs. Their voices appear and disappear in the text like echoes growing fainter with each page.

For Peter Matthiessen, this story was a return to the full-bodied well-being of his youth, to a moment that crystallized his own character and identity, and the flood of personal emotion and romance sweeps us before it in the taut athletic grace of the prose, as Matthiessen, along with the fishermen, lived precariously and worked prodigiously. It is a work fascinating in its detail and powerful in its passion for both place and people. The words take on some of the uncontainable rhythms of the sea, roaring here, whipping up salty anecdotes there, a rambling discursive style rolling technical terms off the page like breakers: fykes and gill nets, haul seining, mashes and trawls, backer and bunker chum. The effect is one of intimate knowledge and physical ease, just as the burrs and knots of their rough speech rings uncannily true: you can hear Cap'n Lester as he spits on the sand and says, turning, "Boys, ain't nothin' doin here, don't look like; let's work back east'rd. . . ."

But as an elegy to his own youth, Matthiessen's text sings a siren's song, celebrates a hero's death, consigns the community—too quickly?—to a watery grave. Furthermore, *Men's Lives* omits or overlooks women's lives. Women are replaced by water and wind, by the shifting treachery of the surf. While the men are out bracing themselves against the tang of night air and cold waves, where are the women? Sitting at tables in those saltbox houses by the lagoons at Louse Bay and Lazy Point, talking, talking, about relatives, illnesses, jobs, children, men, money, about what he said, and she said, and what they feel, about what they have to do to navigate that hard life with

its shifting currents and empty nets, its leaky dories and unexpected waves? Their voices are missed; the story seems incomplete without them. But, of course, Matthiessen is telling his own story here, and has declared his domain: the open sea, and no domestic confines.

The seven photographers—Dan Budnik, Lynn Johnson, Danny Lyon, Evelyn Hofer, Jean Gaumy, Martine Franck, Gilles Peress, and Doug Kuntz—who came and went over a period from 1981 to 1985, some for a month, others for a year, brought to this documentation their own visual codes and aesthetics, an ambiguous mélange of reportage photography coupled with large-format work. The cumulative effect (in which the editing was undoubtedly a dominant factor) is classically heroic, as in Franck's frieze of the Havens crew loading seine into a dory, or Gaumy's mysterious "Passing Montauk Light at Dawn." The innocence of Hofer's portrait of Jarvis and Nancy Wood and the purity of Peress's study of Benny Havens and Steven Meuten underline the perceptible nostalgia of the pictures, and the extensive captions in the back of the book have an air of finality and mortality that enhances that effect.

Last, there was the patron—a curious word, with its musty odor of Baroque chapels—Adelaide de Menil, daughter of the redoubtable art impresario Dominique de Menil. A longtime resident of

East Hampton, De Menil lives in a series of converted barns of great beauty with a potato field all her own stretching from them down the half-mile lane to the beach road. The fishermen in their saltbox houses were a few furlongs from her backyard, and when Doug Kuntz came to her with a suggestion for this project, proximity dictated a neighborly interest, which grew as she employed a succession of photographers, paid them generously, and provided them with housing, cars, and expenses to document the fishermen and their folk; among other support staff for the undertaking, she employed a full-time curator to manage the project, and "encouraged" Peter Matthiessen's text. What did she hope for from *Men's Lives*?

The ambivalence here is that the impetus for this project came from the threat of passage of a highly restrictive bill pending in the legislature, which passed into law in 1983 despite desperate efforts by the fishermen. It limited the legal catch to fish of more than twenty-four inches, and drove what some said was the last nail into the coffin of the commercial fisherman.

So the book, and the exhibition that accompanies it, have taken on the character of a postmortem. If they had any hope of stirring interest, awakening awareness, they have perhaps come too late. One could argue that the project did not confront the political challenges it

Dan Budnik, *Stuart Vorpahl*, 1982

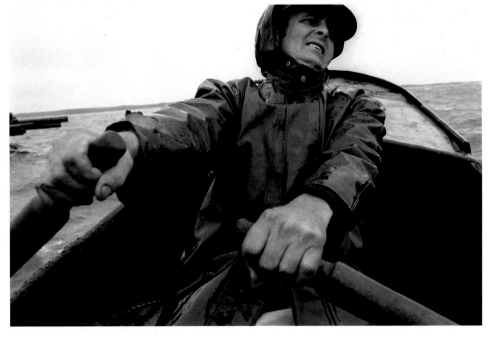

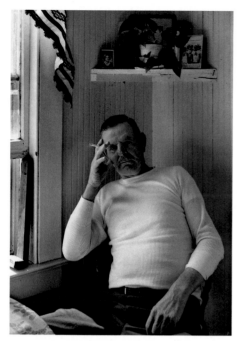

Lynn Johnson, *Captain Sidney Lindbergh* (*"Lindy"*) *Havens, drowned*, 1985

was meant to face; while it succeeds at preserving the memory of those men's lives, it fails to create energy for the future of their children. Nor does it really explain what is their immediate future now that the bill has been passed; it buries Captain Havens with the clear implication that the others will follow him into extinction.

That said, one must further ask whom this book is for. Both the trade edition, handsomely reproduced, with single-tone historical photographs, charming line drawings of some of the four hundred species of fish that frequent Montauk waters, and duotone plates on heavyweight glossy paper, and the two-volume, slip-cased deluxe edition, seem destined for the bookshelves and coffee tables of the new residents who displaced the Bonackers, the city people who occupy those big houses by the Hampton beaches, who would value the reminder of the fishermen's existence for the piquant authenticity it adds to the area.

It is that sense of unease, subtly, intangibly patronizing, confusing itself with the cause of social reform, that makes *Men's Lives* uncomfortably like the Walter Scott epigraph at the front of the book, "It's not fish ye're buyin, it's men's lives."

LIFE'S LINGERING SHADOW
by Fred Ritchin

It has been just over fifty years since *Life* magazine sold out all of its first 466,000 copies and the era of big picture magazines commenced in this country. Since then we have lingered in the shadow of *Life*, bemoaning its absence long after its demise, evoking the magazine's aura by recycling its imagery in periodic shows and books celebrating legendary *Life* photographers.

But it is a different time now. Although we continue to associate ourselves with the magazine's glory, photojournalism has evolved greatly since the weekly *Life* stopped publication fifteen years ago. Nothing that utilizes still photography has ever replaced *Life* in the popular culture, which may explain why the magazine remains a looming influence. But if photojournalism is to move forward from its confused present, we must first acknowledge that much of the best of what *Life* represented to photojournalism does not, for the most part, exist anymore.

Shortly after the weekly *Life* folded, I was introduced to the editorial world of pictures when I started to work for a publisher that produced book series. My experience there, and subsequently at a variety of magazines, made me keenly aware of the nature of the evolution in editorial photography.

When I began, I was given a choice of working either with text or with pictures. In either case, the job would primarily involve research. Since I was most interested in and familiar with words, I began as a text researcher.

The highly formatted text was the creation of many people other than the writer: the researcher who had to verify every word in it, the credentialed expert in the field who acted as a consultant, and, most important, a hierarchy of editors who would edit the text and then each other. The writer remained master neither of his own style, his point of view, nor even the facts. The writer's name sometimes seemed only to be included to uphold the reassuring convention of authorship, positing the existence of a specific, human voice.

After a month, I moved to pictures. My first assignment as a picture researcher was quite different: illustrate a chapter on creativity. Rather than only find images to exemplify points already made in the text, I was encouraged to find an approach in which photographs would be made to work together as an essay to parallel rather than illustrate what had been written.

But I soon learned of the limitations of my new job. In one layout meeting, a photograph of Arthur Rubenstein practicing at the piano, his back ramrod straight, that had been included as an example of the need for discipline in the creative process was rejected because the top editor decided that classical musicians are not creative because they play someone else's music. Only a jazz musician was creative, he said.

But, compared to text, pictures were fun, vital, exciting. Despite interference, this mainstream publisher, like others, would allow photographs to be published that said more than the point they were there to illustrate. The images could be emotionally subtle, complex, even ambiguous. They had an authenticity that seemed to come from life.

Furthermore, while many photographs were rejected for a diversity of reasons that repeatedly confounded much of the staff, editors could not and would not reach inside the guts of photographs to revise them as they would words. A writer was often required to rewrite, or would have his text rewritten for him, because authorship was flexible. But photography was safer than words for a variety of reasons: few editors understood it well enough to know what it was saying, respected its power, or comprehended its structure as a language to the degree necessary to change what was being said, either in the assigning or cropping of photographs. Within it's rectangle, the essence of the photograph was safe from editorial interference in a way that the essence of a paragraph was not. The reader could still respond to the image rather directly, despite its often limiting caption and context. By comparison, the words that were published seemed dry and much more orchestrated.

This sense of unmediated connection between the viewer and what the image represents has perhaps been photojour-

nalism's greatest strength, and the reason for the success of *Life* magazine and others like it. With the similarity of photography to human sight, one could think that one saw the same scene as the photographer and interpret it without relying on the opinions of a mediating human photographer or editor. Only the mechanical, apparently straightforward camera need be relied on. This made photography feel like a democratic medium, accessible to all in its journalistic idiom and providing plenty of information. In contrast, "art" photography, like art in general, was not always so accessible or forthcoming. As Lincoln Kirstein said of Walker Evans's unadorned tenant-farmer photos: "What poet has said as much? What painter has shown as much?"

But in recent years magazine readers have had diminished opportunities. They are no longer allowed the same sense of being at the scene, and the same freedom to interpret photographic imagery according to their own predilections and experiences. Now editorial pictures tend to overpower human vision rather than resemble it. They are more theatrical, better lit, sharper, and more highly colored than seeing itself. Whereas once photographers were encouraged to set up a photograph to match what would normally have happened, to restage it, now it is often required that a photographer contradict and transcend the normal. People must do things in photographs that they are not used to doing—a successful bank president throws money into the air, for example, or poses clothed in gold. Photographs are manufactured rather than elicited, and people are made into powerful cartoon characters. They are entered into a magazine-sponsored drama that, to a sizable extent, has fame as its currency and consumerism as its foundation, with power the unstated religion. Recently the photographs used in advertising often seem as "real."

This emphasis on the supernormal has always been true, but it has rigidified. Among other reasons, editorial photography is now less about seeing the new then it was when *Life* started, since so much has now been seen ("To see life; to see the world; to eyewitness great events; to see strange things . . . ," wrote

Henry Luce in his oft quoted prospectus for *Life*). Television, movies, and a plethora of still imagery in publications and advertising make "seeing the world" *déjà vu*, at least on the superficial, sensory level the world is usually depicted. Instead, boundaries have been artificially drawn to create a class of "new" in terms of fame, as one example. Some are granted celebrity status and are photographed befitting their new status in a way that is similar to the advertising of a luxury car. They are shown as simultaneously off limits and powerful, while being delivered to the reader by an even more powerful publication. (The *Wall Street Journal* recently published an appreciative front-page story on celebrity portraiture.) Magazine photography is to a large extent no longer about observed realities, recorded in the language of human sight, but about the celebration of primarily upscale societal values.

Another tendency in editorial photography is to employ images that are taken from reality and then used only as simpleminded support for the point of view of the more articulate text. If the text says that Ronald Reagan is recovering from the Iran-Contra scandal, for example, he will be shown smiling at the White House. If he is said to be in serious trouble, an image will be chosen in which he looks troubled. A photographer will not be asked to investigate Reagan's true state, but his or her images will be used as stick figures to "prove" ("the camera never lies") the text's point.

Why this constriction in photographic seeing? Perhaps it is because editors thought that world-traveling readers were beginning to be able themselves to see much of what's out there, and to take pictures like those in the magazines, or else were deluged with imagery from television and elsewhere. In response, a decision seems to have been made to fashion images that appear to be more sophisticated, more the work of specialists, and more about what is unattainable. That way both readers and advertisers will think that they are getting something special. Perhaps it's because reality, no longer being new, wasn't exotic enough to show. Or maybe it's because reality was judged to be too disheartening.

Perhaps it is also because as photographs were deemed, post-*Life*, a livening influence on the personalities of publications as both entertainment and a good environment for advertising, editors began to take them more seriously. Gaining in skill, editors were now able to take much of the nuance out of the imagery as they had previously done with words. In any corporation a controlled, known quantity is judged better for mass production than one that requires individualized sensibilities to produce and appeals to the consumer's relish of subtlety and conceptual expansion. Now photographs, like most other consumer goods, avoid ambiguity and seem safe, easily understandable by all concerned.

For example, photographs of the violence in other countries are picked to symbolize what the publications want to say, to play a role in a voyeuristic drama, but without any real, specific presence of their own. The images simplify the violence, the reasons it exists (an almost untouched topic in recent magazine photography), even the atmosphere in which it occurs. It is as if the world, photographically as well as in other ways, has been distilled into one giant, ongoing Iran-Iraq war, with no one really caring about the outcome, with an occasional image to spark the drama and a spectator's interest.

Perhaps, in retrospect, what distinguishes the work of W. Eugne Smith even today is his depiction of a drama between good and evil. Today's depictions, post-Vietnam, have no such moral underpinnings. And without them, it is easy to let photography remain disinterested, in fact celebrating this disinterest in the name of a "journalistic objectivity" that verges on voyeurism without making choices. Smith, it is clear, made choices as few after him have done.

It is symptomatic of this tendency toward the constriction of photographic seeing that the picture essay, at which Smith excelled, has virtually disappeared from the pages of magazines. It is much harder to control a group of images, to direct their multiple meanings. It is significant, I think, that if one selected the top magazine picture essays published in this country, so many of them were done thirty and more years ago. (This is not

to assert that these changes in editorial photography are all completely new. *Life* was certainly manipulative and condescending to its readers, but it could also transcend its glibness was was less intensely cynical and ungiving than today's publications that use photography. In fact, in today's context Henry Luce's statement written before *Life*'s first publication seems almost radical. "We have got to educate people to take pictures seriously," Luce wrote, "and to respect pictures as they do not do now.)

If these tendencies continue, as seems likely, photographic images representing the more mundane and raw realities will retain only a muted voice and the photographer will remain disenfranchised. Occasional mild essays will be published. But no more will visual imagery be allowed to play havoc with the readers' minds as happened during the Vietnam War. Control is preferable, both personal control by executives and corporate control, which largely determines the former. Out-of-control discussion is not seen to be in the interests of mainstream magazines that wish to keep their authority and their appeal to advertisers, who undoubtedly prefer to be showcased in an authoritative publication. An occasional scandal, yes, but not the wild alive voices that can come from photography and, of course, from writing.

There is also an economic incentive that helps determine the photographer's stance on an individual basis. The great explosion of freelance photography after *Life* folded, celebrated then for its ability to add contrasting voices to the journalistic din, has left photographers, like other business people, catering to and competing for a mostly unimaginative and, in this case, largely monolithic market. They hand over film and contact sheets for others to select from, to make whatever point they want to, to contextualize by layout, headlines, and captions, not overly bothered that a writer would never turn over all his notes and drafts to editors to fashion a story from, nor that the editors were never in the places that they were and do not understand what they meant by the various images on the contact sheets. It is no wonder that many photographers have lost their vision, that they work on corporate reports and public-relations projects while al-

luding to their own impotence. It pays better than editorial assignments and it's just as honest, they say.

Perhaps then it is time again to look back at 1936, the year *Life* began, and choose again from the legendary offerings in photojournalistic history of that year. Three others come to mind. The Farm Security Administration documentary photographic project on the United States' rural poor, unrivaled since in its scope and execution, was in full swing. In Europe young Robert Capa was taking perhaps the most famous war photograph of all time, of the falling soldier in the Spanish civil war, an image that is once again in the limelight over allegations that it was staged. On this side of the Atlantic, Walker Evans and the writer James Agee were in Alabama collaborating on the failed *Fortune*-magazine assignment that would become the classic book *Let Us Now Praise Famous Men*.

Perhaps we still have something to learn from these models. War photographer Capa, for example, known for his "If your pictures aren't good enough, then you aren't close enough" bravado combined with caring, has served as a model for the "concerned photographer." Now is it more "concerned" to continue to make vivid images of war and other social problems as Capa and a legion of others like him have done, or are there other, more productive strategies to affect a readership that has seen thousands and thousands of such images? Perhaps the torch of "concerned photography" now burns brightly but differently in the hands of someone like John Vink, this past year's recipient of the W. Eugene Smith grant in humanistic photography, who plans to document the role of water in Africa's Sahel in an approach to climatic disaster that avoids photojournalism's graphic preoccupation with victims to concentrate on process.

Perhaps the Farm Security Administration project can be used as a productive model by photographers willing to work in groups on large-scale social issues. The recent book *El Salvador*, containing the work of thirty photographers, is one example of a combined effort. It seems inevitable that large documentary projects will make their presence felt as effective strategies are thought of to document problems that in some cases have

hardly abated in the fifty years since the FSA, and in some cases intensified. It is clear that the main stumbling point, conceptually, is that the moving images of the FSA photographers of victimized people cannot, with effect, simply be repeated, even though photography excels at such depictions. Much else can and must be explored, about rich and poor, here and abroad, with an eye both to analyses and to helpful alternatives.

Of the models mentioned from 1936, it is probably Walker Evans's work with James Agee on *Let Us Now Praise Famous Men* that is the most employed by photojournalists seeking alternative forms of presentation. There is an unprecedented number of photojournalists publishing books on timely issues—homelessness, Latin American peasantry, poverty in the United States—that they not only hand in the pictures for but author photographs in more substantive ways. Independently produced audiovisuals are also surfacing on a diversity of topics—South African politics, the women of Nicaragua, a low-income housing project in Boston that is being replaced largely by upper-middle-class housing, the gentrification of East Harlem.

But it seems to me that those in and outside of photojournalism have to reach considerably beyond the models of 1936 and come up with new intentions, new forms, new strategies of production. It is clear that *Life* is no longer a viable flagship, even in memory. It is also evident that the witnessing function of the photographer has to be combined with analytical skills, as well as editorial and marketing abilities that will allow a more sophisticated dissemination of work. A partnership of photographers, editors, and business people must be implemented to provide a structure and support for these efforts here and abroad.

More than anyone else, members of the photographic community have an obligation to aggressively support these efforts, financially and in other ways, if they are to succeed. One can no longer simply worry about one's own personal stake, assuming that proper conduits for expression will exist. Otherwise, photojournalism will become increasingly inarticulate and remote from human experience, and leave us all behind.